MEDIA MANUALS

Using Videotape

MEDIA MANUALS

TV CAMERA OPERATION
Gerald Millerson

BASIC TV STAGING
Gerald Millerson

THE USE OF MICROPHONES
Alec Nisbett

YOUR FILM & THE LAB
Bernard Happé

TV SOUND OPERATIONS
Glyn Alkin

TV LIGHTING METHODS
Gerald Millerson

16mm FILM CUTTING
John Burder

USING VIDEOTAPE
J. F. Robinson, & P. H. Beards

THE SMALL TV STUDIO
Alan Bermingham, Michael Talbot-Smith,
John Symons, & Ken Angold-Stephens.

EFFECTIVE TV PRODUCTION
Gerald Millerson

THE ANIMATION STAND
Zoran Perisic

THE LENS IN ACTION
Sidney F. Ray

Forthcoming titles

The Lens & All Its Jobs
Scriptwriting for Animation
Sound Recording & Reproduction
Motion Picture Camera Equipment—Choice & Technique
Basic Film Technique
Creating Special Effects for TV & Films
Script Continuity and the Production Secretary — in Films & TV

Using
Videotape

J. F. Robinson,
P. H. Beards

A Focal Press Book

Communication Arts Books
HASTINGS HOUSE, PUBLISHERS
New York, NY 10016

ISBN 0 8038 7500 2

Library of Congress Catalog Card Number: 76-43565

Ap 7 77

Printed and bound in Great Britain by Staples Printers Ltd., Kettering, Northants

Contents

Introduction

Videotape recording is now well established in broadcasting and many techniques have been developed to get the best results from this highly complex but useful medium. Television, however, is no longer the exclusive realm of the broadcaster. Industry, hospitals, schools and police, among others, have all adapted it for their own purposes. One of the most important requirements in all these applications has been the ability to record the television signal and replay it later; videotape recorders are almost exclusively used for this purpose.

Very often the user of VTR is disappointed with the results he gets and is confused by the wide variety of accessories available to him. He is frequently given conflicting statements concerning what can be done and what cannot be done. Most information written on the subject is either biased or highly technical.

This is a users book. It helps the user to get the best results from a videotape recorder. It explains the purpose of the wide variety of accessories available and details the applications for which they are most useful. It gives hints on editing, mixing, adjustments, causes of faults, indexing of tapes, and includes a glossary which explains the technical jargon in simple terms. Several sections are included on the fundamentals of television and magnetic recording so that the basic problems of videotape recorders can be understood. Common questions have been answered and a minimum knowledge of the subject is assumed.

The authors wish to thank the following organisations for help and permission to reproduce some of the diagrams in this book.

Ampex Corporation
British Broadcasting Corporation
Committee Consultative International Radio
European Broadcasting Union
International Video Corporation
Philips Electrical Ltd.
Plymouth Polytechnic
Radio Corporation of America
Society of Motion Picture and Television Engineers
Sony Corporation
3M (United Kingdom) Ltd.

VTR in Education

Second only to the text book, television has shown itself to be a most important audio visual aid. It does not replace the instructor or lecturer and it certainly should not be used by itself. Its main advantages are that:

1. It holds attention, for short periods, against most other external stimuli.
2. It permits a larger audience to receive information from experts and specialists.
3. Complex demonstrations can be prepared, set-up and recorded beforehand. This releases the lecturer to concentrate on his presentation.
4. Recordings can be played back again and again, saving considerable time.
5. A television camera can get closer to moving machinery and in to more remote places than groups of people; it can also be clinically germ free. With special lenses micro and macro techniques can be used.
6. Sound levels of noisy processes can be adjusted to allow comments or explanations to be heard.
7. With a video tape the student can go over the main points afterwards at his leisure.

The main disadvantage of television for instruction is that communication is one way. Audience participation is rarely practicable. It is also difficult to hold the attention of the audience.

It is not worth making a videotape unless it is to be used several times. It takes *at least* five times longer to prepare a tape than to give a straight talk or demonstration. The recording therefore should need to be used at least five times. Programme duration should not exceed 30 minutes. Only the main points of information should be included and the class prepared beforehand so that they know what to watch for.

Follow-up is important. The instructor should go over the main points and expand them, ask questions and generally stimulate discussion. A practical demonstration should be followed by a practical period where the class has to put into practice what they have seen.

Using colour
Apart from having more impact a colour picture contains far more information than a monochrome one. In education this can be very important and in some subjects like surgery, colour is essential. Consider carefully before investing in equipment whether colour is required in the near future. Some VTR's can be easily converted to colour while others are monochrome only.

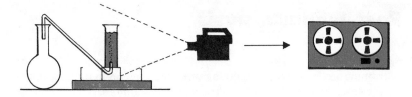

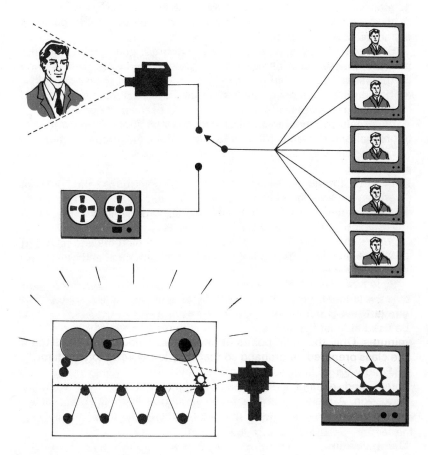

VIDEO APPLIED TO TEACHING

Recording demonstrations
Complex experiments can be recorded and played back many times.

Distribution
Video can easily be distributed to reach a wider audience.

Isolation
A video camera can isolate the viewer from dangerous or noisy environments.

Post-Event Analysis

Sport
VTR has become indispensable for serious coaching in any sport. It is most useful where refinement of technique is required.

It is used in team sports such as football, netball and hockey where team manouevres can be rehearsed and analysed collectively during training, and post mortems made after matches. For such purposes the camera should be as high as possible and set to a wide angle to encompass as much of the playing area as possible.

Self analysis in individual events such as golf, tennis, boxing, gymnastics, skating, athletics, diving, show jumping, etc., is simplified by the use of VTR. Experiments in techniques can be analysed in slow motion and still frame until perfected. For coaching purposes the trainee can compare his technique with that of the professional.

In competitive events, a TV camera and VTR allow a "photo-finish" to be analysed instantly. No development of the videotape is required.

Medical
Television admits a wider audience to operations and medical diagnosis without the risk of infection. VTR allows these events to be recorded either for student instruction or later analysis. For most medical applications colour is regarded as essential.

X-rays can be readily converted to television pictures and recorded on VTR, a technique particularly useful for barium meal and other time sequential X-ray analysis.

Study of mental disorders sometimes requires observation over long periods of time. VTR allows later analysis of interviews and reactions to be compared during a course of treatment.

Industrial
A camera and VTR can be set up in most industrial situations where time and motion study is required.

The analysis can be done completely from the VTR playback allowing the minimum of time and fuss at shop floor level. All results can be checked by repeating the playback and small timings can be made more accurately using slow motion.

It is sometimes convenient to record the time with the picture. This can be done either by including a clock with a sweeping second hand in the recorded picture or by superimposing the time electronically from a clocked character generator.

There are many industrial processes where observation is either too dangerous or inaccessible for humans. A television system is the answer. Stroboscopic techniques as used in vibration testing can be readily adapted for use with television. It can also be used to freeze very fast action where the 1/50 sec field of the TV system is too long.

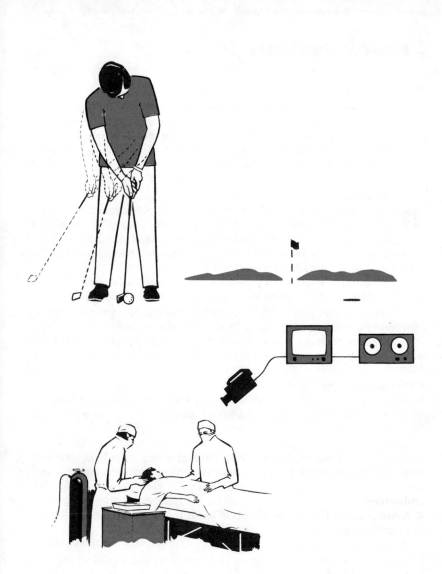

VIDEO FOR ANALYSIS

Movement in sport
With frame by frame inspection a sportsman can analyse his own action and that
of an instructor or competitor.

In difficult situations
Recordings can be made for future instruction or analyses. A camera is small,
silent and germ-free. It should be mounted out of the way, but at a vantage point.

Security Systems

Television is ideal for surveillance in large department stores, banks, libraries, warehouses, remote installations and traffic junctions. The output of several cameras can be conveniently monitored by one person. VTR is a useful addition to such installations because any camera output can be selected for recording when required. This can provide useful evidence at a later date.

Time lapse recording
Specially adapted helical VTR's offer the facility of recording only one TV field in every 50 (one a second) from a standard television camera. This extends the capacity of a standard one hour tape to 50 hours. The tape can be played back at any speed and give a quick security check over the previous two days.

Systems vary, some giving a choice of extensions from 6, 12, 24, 48, to 72 hours. Most manufacturers produce time-lapse recorders which give a tape compatible with their conventional recorders, thus allowing one hour rapid playback of the recorded material.

Time-lapse recorders are very economical and can be used to survey high security areas around the clock.

Police communication
Television provides rapid communications via microwave link between police stations. At police headquarters programmes are assembled, on videotape, of lost items, stolen cars, missing or wanted persons and general information.

The tape is then replayed to other stations and viewed by officers when they come on duty. Apart from the speed at which information can be disseminated it is felt that there is more likelihood of the information being seen and remembered than if any other form of distribution were used.

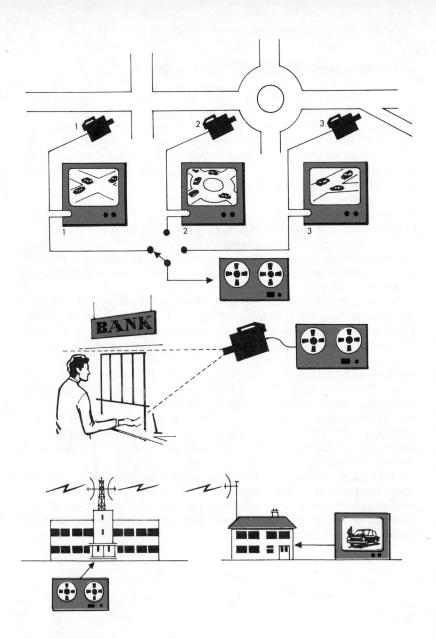

POLICE WORK

Multiple observation
Any one of several observation points can be selected for recording.

Security
Continuous time lapse recording or a silent alarm system can aid identification.

Communication
Information can be recorded and rapidly passed on to outlying areas.

15

Communication Methods

All large organisations whether university campus, hospital group, government department or international company, have the problem of communication. The mass of this information is carried verbally or through the written word. There are many occasions when more information or more impact are required and VTR is an economical way of filling this requirement.

Among the uses it has already been put to are:

1. Tapes in which top management of the parent company explain company policy to executives of subsidiaries.

2. Communications from managing director to shop floor. Most employees wish to see and recognise the top management. In large organisations this is not possible, but an annual videotape can help to bridge the gap.

3. Communications from directors to shareholders. A well prepared videotape showing new installations, products, and latest developments can be shown at shareholders meetings. Graphic representation of indigestible figures can put over reasons for company policy.

4. Assembly instructions can be demonstrated very readily on a videotape to accompany the kit of parts. This application is sometimes more economical than comprehensive written instructions.

5. In cases of disaster or breakdown, a videotape made on site showing the extent of the damage can be worth a thousand still photographs. Effects that are difficult to describe can easily be demonstrated to send back to headquarters.

6. Now that domestic VTR's are becoming established for the recording of transmitted programmes, it is a short step to prepare messages on tape to send to distant relatives and friends.

Contact

Directors of organisations can be seen by all in regular communications between the board and the work force.

Impact

Statistics can be simply and illustratively portrayed by adding graphics. This addition adds interest to the annual report.

Insight

Recorded pictures of problems in the field can speak a thousand words in a report at base. With instant replay the result can be checked before leaving the site.

Personal

Messages can be recorded and sent to friends and family anywhere in the world.

Demonstrations and Sales Aids

Sometimes it is difficult for a company representative to demonstrate fully all the applications of a product. A well prepared videotape can show such products in use or perhaps show interviews with other users who have found satisfaction with a product. Tapes should be kept short, five to ten minutes at the most. The recording should be used to show the prospective customer something that would otherwise be difficult for the representative to show. Facts and figures are difficult to remember from a TV programme and are easier to give afterwards.

TV advertising
Television advertising is now well established and many agencies are involved in preparing commercials. A VTR can help an agency prepare a commercial and demonstrate to a client the various possibilities.

The main advantage, apart from the ease of production, is that the client sees the programme exactly as a viewer at home would see it.

The VTR is also useful for consumer research because it allows several adverts to be tried on small groups to assess reaction.

Advertising time is an expensive item and sometimes a commercial gets clipped when schedules are tight. A loss of vision or severe distortion can easily cause an advertisement to lose its impact. Many companies check the broadcast output and claim for any errors. An off air VTR recording gives a permanent record of timing and quality and can be used to demonstrate the sequence again.

Point-of-sale aids
A closed-circuit TV installation at exhibitions or supermarkets gives contact with a prospective buyer at the time he is ready to buy. A videotape can be prepared showing the special offers, reductions and new items on television monitors placed in strategic positions. Videotapes can be replayed many times and items changed, with the aid of an editor, when required.

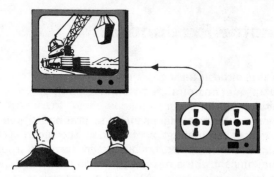

OR

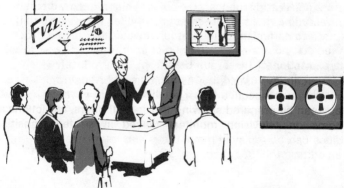

PUBLICITY

Actions speak louder than words
Examples of equipment in action can easily be shown to a prospective customer.

Commercials
Decisions on television commercials are best made by assessing them on a monitor screen in a similar environment to the viewer.

Demonstrations
A television screen never fails to attract attention and is a useful adjunct to demonstrations, sales conferences and exhibitions.

19

Programme Production

Non television production
VTR can play an important part during rehearsals of stage plays, live entertainment or for films.

For stage work the television camera should be set to a wide-shot at some vantage point and then forgotten while the VTR records. Close-ups should be avoided because they have no application to stage productions and can provide a misplaced emphasis.

The VTR playback can be used by the performers to study their movements and mannerisms with respect to other artists, props and the stage in general. It is also useful to the producer because he can explain more clearly to an artist where things are awkward or how the actions did not co-ordinate.

For film the VTR is useful to the director to try and preview shots and effects before committing film footage. Actors can use it to check emphasis and expressions on difficult scenes.

Television production
A videotape recorder is not simply a recorder of television productions. With electronic editing it is a production tool in itself allowing complex scenes and costume changes, fast cutting, flashbacks and special effects, all impossible without VTR.

Because VTR production is time consuming automated editing has been developed in the broadcast industry which allows a computer to control the editing functions. All that is required from the producer is to feed in the edit points in the form of picture frame numbers. However, it is the extraction of these numbers from the producer which is the most difficult and time consuming process in the first place.

To help the producer in this task a helical recorder can be used with a work copy of all the scenes to be used. Superimposed on the helical vision are the address frame numbers used by the editor.

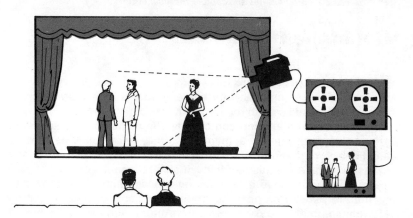

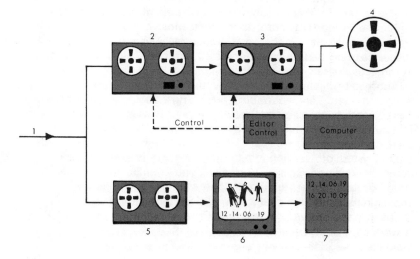

PRODUCTION CONTROL

Stage drama

Movements can be improved by analysing rehearsals with the artists. A wide angle shot is more useful than close-ups.

Video editing

The video and audio signals (1) are recorded on a cheap helical machine (5) at the same time as the expensive broadcast machine (2). Production decisions can then be made by viewing the scenes (6) and noting the edit points (7). This information can then be used to assemble the programme (3) onto the final tape (4). This entails the minimum of time on the higher cost recorders.

21

VTR in the Home

Several products are available for the *playback* of television programmes on a domestic receiver, but only a videotape *recorder* allows the domestic user to record his own programmes.

The recorded programme can be any TV programme broadcast in your locality and can be a favourite family show, cinema film or educational programme. Students enrolled on courses with the University of the Air would find it invaluable to repeat lectures.

Some recorders have a built in tuner which enables a viewer to watch a programme on one channel while recording the programme being transmitted on another. Some are fitted with time switches to switch themselves on and record the programme while the owner is out.

The major requirement for the domestic recorder is that it should be simple to use. For this reason most models are of the cassette type.

Another important factor is its cost. Most colour-capable models are about the same price as a colour receiver but the cost of the cassettes must also be considered: 20 one-hour cassettes cost about as much as the recorder itself.

Another possible requirement would be to record home pictures. Some models are portable, weighing about 16lb, including rechargeable batteries giving about one hour playing or recording time. The camera is normally extra but the pictures can be played on the domestic receiver.

One word of warning when the recorder is playing back on a domestic receiver. This is normally done by placing the video and sound on to a carrier tuned to a spare channel not being used locally. This signal can radiate over a few yards and be picked up on a nearby receiver. *Care should be taken with tapes of a personal or secret nature!*

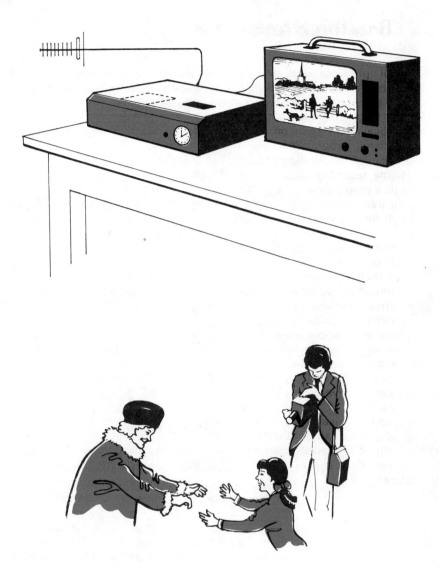

IN THE HOME

Off-air recording
With a time switch a cassette recorder can record a transmitted programme for later viewing. If the recorder has a tuner fitted, one channel can be recorded while viewing another. The recorder is simply plugged into the aerial socket.

Recording home events
If the recorder has a 'Video-in' socket then recording from a video camera is possible. Instant playback means that results can be checked immediately.

Educational Networks

Most educational networks rely heavily on VTR for two reasons.
1. The programmes are generally complex because they are trying to achieve something which would otherwise be difficult.
2. The programmes are normally repeated several times.
 There are several sources of programmes which all focus on to the VTR department.

Distribution systems
The distribution can be done in two ways.
Distribution System A uses a post-office line. The line is rented and can carry several channels which normally includes broadcast transmissions. Permission should be obtained, for the recording of broadcast programmes.
Distribution System B is via a tape library with a cassette recorder in each school. The advantages of the system are:
1. It is more flexible because the school can replay programmes when required and does not need to wait for transmission.
2. Off-air recording is possible at each school. This reduces the work load in the VTR department.
3. With the addition of an extra camera the school can record its own material.

Comparative costs
System A: Studio + OB unit + VTR Dept + Line rental + TV Receivers.
System B: Studio + OB unit + VTR Dept + Cassette Recorders + TV Receivers.
In both systems the studio, OB unit and VTR dept are substantially the same, although the VTR section in system B requires extra cassette recorders for dubbing. This is more than offset by the more economical use of the two-inch master machines as dubbing can be done around the clock.
 The economic advantage of either system hinges around the cost of line rental against the cost of a cassette recorder. Line rental depends on the geographical layout of the schools but in urban areas it is likely to be more than the hire of a VCR plus maintenance. The cost of cassettes must, however, be taken into account. This increases with the number of programmes while the cost of line rental with multi-channel capacity is constant until it is fully utilized.

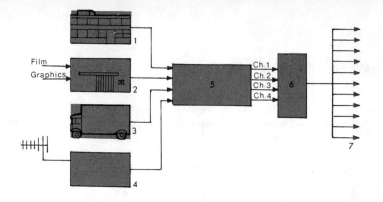

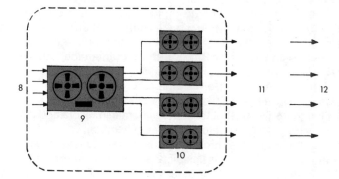

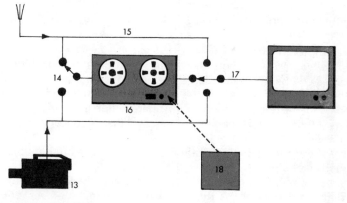

EDUCATIONAL TELEVISION

Cable distribution

Inputs from school (1) studio (2) outside broadcasts (3) and off-air (4) can be recorded (5) distributed via cable (6) to schools (7) in town.

Tape distribution

The same inputs (8) can be dubbed on to cassettes (10) and distributed to schools (12) from a central library (11).

Connections in the school

Three sources of material are available for viewing: off-air signals (15) library tapes (18) and local camera (13). These can be brought in by switching (14, 17) either direct or through a VTR machine to the school receiver.

Film versus VTR

Videotape is now doing a lot of the work originally done by film. It has not completely eliminated film and probably never will. The advantages of each medium should be clearly understood.

Advantages of tape

Ease of use. Television is immediate. Errors in exposure, picture content, focusing can be corrected instantly. Videotape requires no processing so that the whole programme can be previewed before scenery or experiments are de-rigged and performers sent home.

Cost. The television production is quicker than the equivalent film production and is therefore cheaper. The cost of one hour of colour film and processing is of the same order as videotape, but with erasure, videotape can be used again and again. The average user should get at least 200 head passes from a tape.

Editing. Physical editing is easier on film but with the advent of electronic editing the VTR is less messy, just as flexible and allows for the previewing of a splice before it is actually made.

Even for large scale production, automated techniques in electronic editing gives a speed and flexibility unobtainable with film:

Sound is far less of a problem with tape. The separation between sound and vision on tape is not a problem with electronic editing.

Distribution. Video signals are easy to distribute. TV monitors can be mounted in several locations and fed from one static VTR installation.

Advantages of film

Multiple copies. Although the initial cost of a film is high, cost becomes competitive when large numbers of copies are required. The turnover point depends on the production, film standard (16mm, 8mm) and the type of format considered. For a comparable CCTV quality if more than 10 copies are required then a cost analysis should be done.

Mobility. Even with miniaturization a film camera is more mobile than its equivalent VTR.

Standardization. Standardization on film is well established. It is also multistandard throughout the world (unlike television). A 16mm or 8mm film can be sent to central Africa or Peru with reasonable confidence that a suitable projector can be found.

Animation. Animation is certainly easier and less expensive with film. Picture stability of TV Cameras is rarely good enough for animation.

Maintenance. Both film cameras and VTR require specialised maintenance. If an experienced technician cannot be employed then consider taking out a maintenance contract.

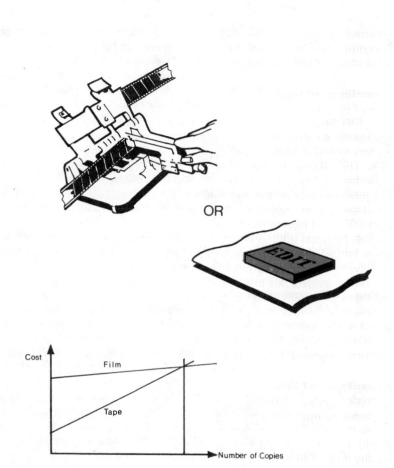

OR

FILM VERSUS TAPE

Tape is normally edited electronically while film is still physically joined. The
initial cost of an electronic production is normally less but dubbing extra tapes is
more expensive than printing films.
A calculation should be made, prior to production, taking this into account.
The physical cutting of tape is possible but electronic assembly of programmes is
recommended.

Television Systems

The TV system begins with the TV camera. The camera lens focuses an image of the scene to be transmitted on to the face of an electronic pick-up tube inside it. This tube produces an electrical signal called the picture signal (see page 38) by scanning the image with an electron beam in a series of horizontal lines, rather as one would read a page of a book (see page 36). At any instant the size of the signal depends on the light intensity of the part of the image being scanned.

Transmission systems

The object now is to transmit the signal so that eventually it is connected to a cathode ray tube which reproduces the original image. Basically there are two types of transmission system:

1. *The broadcast system.* The signal is fed from the studio centre to a transmitting station where it is superimposed (modulated) upon a radio carrier and transmitted as radio waves to domestic TV receivers.
2. *Closed circuit television (CCTV).* The signal is fed directly by cable to a restricted number of viewing monitors.

Colour coding methods

Where colour is involved the TV camera simultaneously scans the image through several different camera tubes (usually three) whose signals can be coded into one ingeniously complex signal. There are a number of methods of coding, the first of which was used in the USA and called the NTSC system — the initials of the committee which specified the standards the system should meet. Since then a number of other coding methods have been invented, the most common being PAL and SECAM and the choice of system has been a matter of controversy in some countries. In the context of VTR we need not concern ourselves with the nature of these coding processes because, basically, all a VTR does is to record the signal connected to it.

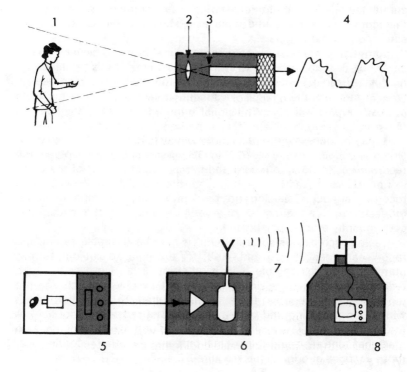

TELEVISION SYSTEMS

Television camera
The scene (1) to be televised is focused by the lens (2) on to a camera tube (3) which converts the focused image into an electrical signal (4).

Broadcast television
After leaving the studio (5) the signal is fed to the transmitting station (6) which broadcasts the signal as radio waves (7) for domestic reception (8).

29

Requirements of a Video Recorder

In its simplest form a videotape recorder requires a video input signal whose voltage has, by general agreement, been fixed at what we call standard level (the term is more fully explained on page 38). Having recorded the video over its whole frequency range (bandwidth) it will then replay the signal, again at standard level, so that it can be connected to a TV monitor for viewing. The recorder must also be able to record and replay sound (also at a standard level prescribed for sound) on the same tape.

Sometimes it is required to record a signal from a receiver – an off-air signal. Both the sound and vision components of this signal will be modulated radio frequencies which are too high to be recorded on tape. In this case the recorder must contain the circuitry to demodulate both sound and vision down to their normal form before they can be recorded.

It may be necessary to record and replay colour signals. The colour signal is coded into the video frequency band and in principle all the recorder has to do is to record and replay colour as part of the video signal. However, certain signal distortions which may occur in a recorder although causing no perceptible picture impairment on monochrome, can affect colour very seriously so the circuitry is consequently more sophisticated.

Having recorded video and sound it may be desirable to edit the tape (see pages 96, 98 and 100); for example, to cut out surplus material or to reassemble it in a different order. On a sound tape recorder this process is simply carried out by physically cutting the tape and joining together the sections required. This is more difficult with video recording and with many types of recorder impossible. A more convenient process is electronic editing which requires two machines, one replaying the original tape and the other recording only those sections of original tape required.

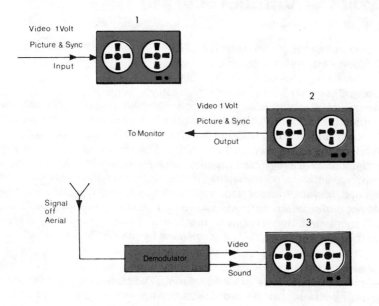

VIDEO RECORDER

Video record and replay

In its record mode the VTR records standard level video and sound signals (1)
and in its replay mode it replays these signals for reproduction on a picture
monitor and loudspeaker (2).

Off air recording

To record a broadcast signal the VTR (3) must contain certain circuitry to
demodulate it into normal video and sound signals.

Electronic editing

In the process of electronic editing one VTR (4) is needed to replay the original
recording and another (5) to record only those parts required for the final version.

Types of Video Recorder

Broadly speaking there are two types of video tape recorder — quadruplex and helical.

Quadruplex

A quadruplex recorder is one which has four recording heads (as compared with one in a sound recorder) to record the video signal. They are mounted on a rotating drum so that as the tape is pulled past the drum, tracks are recorded across the tape almost at right angles to its direction of travel. This type of machine was the first to be able to reproduce video signals enabling stable pictures of good quality to be obtained. It was developed for the broadcasting organizations and has subsequently been refined to record colour and to facilitate sophisticated editing. However, the cost of these machines is so high that they are not available to many would be users of video recorders.

Helical

Helical machines were designed for CCTV users but are now also used, to some extent, by broadcasters. The term helical refers to the manner in which the tape is wrapped round a stationary drum containing one or two rotating heads. The tape is in a continuous motion as the heads rotate and record slanting tracks on the tape. The price of such machines is dramatically less than for quadruplex and even colour machines are available for about the same price as a colour receiver.

Cassettes

One of the faster growing trends in the field of both sound and videotape recorders is the tape cassette which operates on the same reel to reel principle as conventional machines. It is a convenient method of storing a tape and avoids the tedious lace-up procedure because only simple plug-in action is required. In consequence the tape is less likely to be damaged.

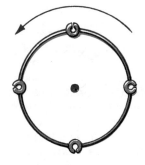

Quadruplex recorder
Four heads are mounted on a
rotating drum. The tape is pulled
past the heads and records tracks
which are almost at right angles to
the tape movement.

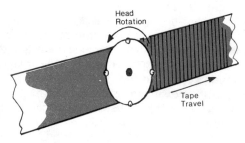

Helical recorder
The tape slides in a helical path over
a stationary drum. The head(s) rotate
on a wheel inside the drum but
protrude through a slit to scan the
tape and produce slanting tracks.

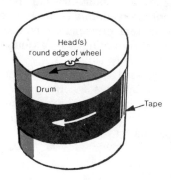

The Sound Signal

In response to sound waves a microphone produces a low level signal. This must first of all be amplified and in this or any other process the shape and relative proportions of the waveform should not be distorted. For the pure sounding notes from certain wind instruments the waveshapes are simple, but from string instruments, for example, and the human voice they are complex.

Apart from size (volume) and shape the other fundamental property of a sound wave is its frequency or pitch i.e. the number of complete waves or cycles occurring per second – technically called the number of hertz (Hz). Doubling of frequency corresponds to an octave rise. Sound sources have different frequency bands within the audio range and a good quality recorder should be able to reproduce the whole spectrum.

Sound volume (level) meters

Two types of meter are used for measuring the volume of sound signal. One is the peak programme meter. It is a sophisticated instrument which is fast-acting and which measures the volume of short transient sounds or continuous notes equally well. It is customary to line up any sound system so that the volume never exceeds 6 on the scale. If it does then overloading of any part of the system may take place with the result that the waveshapes may become distorted and result in poor quality.

More commonly used is the VU (volume unit) meter because it is cheaper. Any signal causing the meter to read to the right of the 0dB line is likely to overload the system. The dB (decibel) scale refers to a comparison between the signal being measured, and a standard volume or level. A positive reading in dBs is above the standard, and negative reading is below it. One disadvantage of the VU meter is that it is slow acting so that short transients do not register their full volume.

However, if, to avoid overloading, signal levels are kept well below the 0 level reading then unwanted noise produced in the recording process is comparable with the signal. Every drop of 6dB constitutes a halving of the size of the signal i.e. −6dB is half maximum, −12dB one quarter and so on.

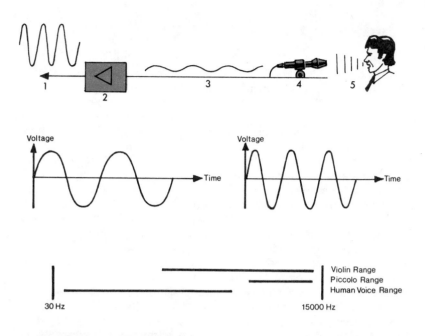

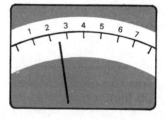

Violin Range
Piccolo Range
Human Voice Range

30 Hz 15000 Hz

SOUND SIGNAL

Waves and frequency

A microphone (4) is used to convert sound waves (5) into an electrical signal (3).
The microphone output volume is low and must be amplified (2) to provide a
stronger signal (1).

If a signal is raised in pitch by 1 octave, frequency is doubled. The frequency
spectrum of various sound sources differs.

Volume measuring meters

The peak programme meter *(left)* is a fast acting meter which accurately
measures maximum volume. The sound chain should be lined up so that to avoid
distortion signals do not cause readings in excess of 6. With the volume unit
meter *(right)* sound signals should not produce readings of over 0 dB. However,
since it is not fast acting, short transient signals do not register fully and may
become distorted even though they do not produce readings over 0 dB.

35

Building up a TV Picture

A TV picture is built up by an electron beam scanning the face of a cathode ray tube (CRT) in a pattern of horizontal lines. The beam makes one left to right trace to produce each line. After completing one line the beam is cut off (line blanking) and flies back from right to left, ready to begin the next line. In essence, the scanning process is like reading a book. When the bottom of the screen (or page) is reached, the beam flies back to the top to begin another complete scanning pattern. (During this flyback period, the spot is again extinguished; frame or field blanking.) In Europe we have standardized on 625 lines per picture. When we come to consider the video signal, we shall see how the spot brightness can be varied to make up a picture.

The picture standard of 625 lines has been chosen to give an image in which the line structure is fine enough to be unobtrusive, and to permit appreciable detail to be produced. Another factor which must be taken into account is the picture frequency (complete pictures each second), which must be high enough to give a realistic portrayal of scene movement and also an imperceptible brightness flicker. In a simple line by line scanning process, 50 pictures per second would be required to achieve this. But such a standard would necessitate circuits being able to handle impractically high frequencies.

Interlacing

Instead, it is found that this wide frequency range can be halved – yet without flicker becoming more perceptible – if a process known as interlaced scanning is used. With a picture frequency of only 25 a second, *alternate lines* are scanned in each vertical sweep, the remainder being interlaced between them in the following vertical sweep. The picture is now made up of 2 interlaced vertical scans – called fields – each covering half of the total number of lines. In the 625 line picture each field will be of $312\frac{1}{2}$ lines.

A finite time is required to complete the vertical flyback and 25 lines are lost during each field, the beam being blanked out for this period. Consequently, the actual number of visible or active lines in the TV picture number 575, i.e. $625 - 2 \times 25$.

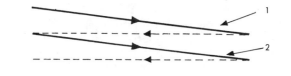

Scanning
Scanning lines have a slight (though imperceptible) slope because the beam is subject to simultaneous horizontal and vertical direction. On flyback the deflection is faster and the paths invisible because the spot is blanked off.

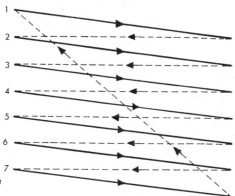

Interlaced scanning
The usual method is to scan alternate lines in one field and complete the picture by scanning the remainder in a second field.

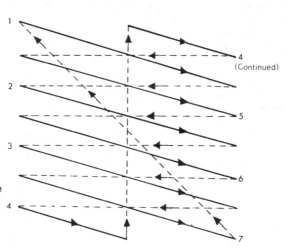

(Continued)

The Video Monochrome Signal

Now we must consider the nature of the signal to be recorded. To make the scanning pattern into a picture the strength of the beam must be varied (modulated) by a picture signal. The maximum value of this signal is called its *white level* – and at this strength the beam produces a bright spot so that the screen appears white. At the minimum video strength (its *black level*), the beam is cut off, and the screen appears black. The picture signal can have any value between these extremes to produce a range of greys. Between lines of picture signal there are brief picture-free intervals (blanking) during which the signal is held at black level while the beam flies back from right to left of the picture (flyback period).

Sync signal

The picture signal contains the information to modulate the beam so that each picture element is of the correct brightness. A further signal is necessary to keep the scanning beam in the receiver picture-tube in step with the beam in the TV camera-tube which produces the picture signal. This ensures that all picture elements are in their correct relative positions and is called the synchronizing (sync) signal. It consists of a series of brief pulses opposite in polarity to the picture signal. The sync signal contains two different types of pulse:

1. The horizontal or *line* sync pulse which makes the beam return (flyback) horizontally at the same time as the camera beam. It is a short-duration pulse going from black level in the opposite polarity to the picture signal.

2. The vertical or *field* sync pulse which synchronizes the picture-tube with the camera in a vertical direction. This pulse has a complicated form, because fields alternate between ending with a whole line and ending with a half line. This automatically provides accurately interlaced sets of scanning lines. This field sync pulse, detectable by receiver circuits, is a train of five pulses each much longer in duration than a line sync.

The complete picture plus sync signal is called a video signal. It is said to be at *standard level* when its overall value is 1 volt. Of this 0.7 volt should be picture and 0.3 volt sync.

The difficulty with recording video is the range of frequencies involved. For a sound signal, up to 15000 cycles per second (15 kHz) is required but for high quality vision it is about 5,000,000 Hz i.e. 5 MHz. Some CCTV recorders restrict the upper frequency limit to 3 MHz or even 1 MHz. This reduces picture definition but saves tape.

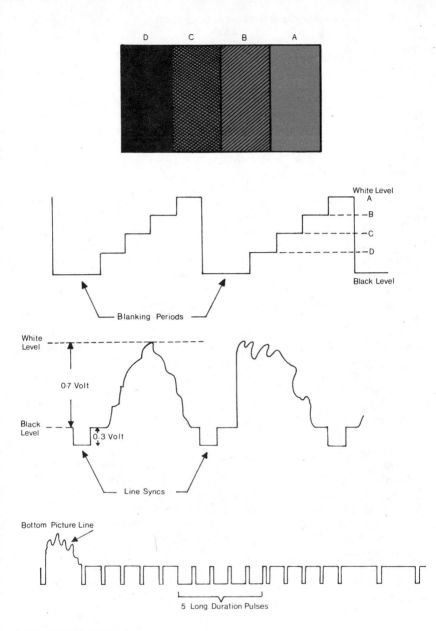

MONOCHROME SIGNAL

Picture signal
The varying brightnesses (A, B, C, D) of the scene are converted into varying picture signal voltages. Blanking periods between lines of picture signal allow time for flyback.

Synchronous (sync) pulses
Pulses are added at the end of each line and at the end of each field to keep camera and receiver scans in step.

39

To the monochrome signal, we add the colour components.

The Video Colour Signal

Rather than use a completely separate signal, colour has been added to monochrome to form a composite or coded signal. The monochrome part of the signal is called luminance and the additional part which colours it is called chroma. If a colour signal is received by a monochrome receiver it disregards the chroma and produces a satisfactory monochrome picture.

A specimen of colour in a scene has a certain degree of brightness which is represented in the TV signal by the luminance component. In addition the colour may be said to have hue and saturation. Hue is the correct term for what we call the colour of an object, e.g. it is red or yellow, etc. Saturation is the purity of a colour, heavily saturated meaning that the colour is vivid, while desaturated indicates pale or pastel shades. For example, blood is a saturated red while a pink rose is desaturated red.

To add these qualities, consider the signal (representing chroma) of which just two cycles are shown in the illustration at 1a. If, quite arbitrarily, we say that this represents blue, then by inverting it to 1b it becomes yellow. This is called a phase inversion. Two other phase values are shown for red (1c) and its opposite colour, technically called cyan (1d). In between phase values represent all other hues.

The strength of the chroma signal increases with the degree of colour saturation in the subject. For a monochrome picture saturation is zero so the chroma signal also falls to zero.

Colour Burst
The trouble with using the phase of a signal to indicate hue, is that by the time the TV signal reaches the receiver, the original phase of the signal would be unknown unless we make a point of relating it to a special reference signal which is transmitted with it. This phase reference point is called the *colour burst*. A few cycles of this reference frequency burst of known phase are added to the transmitted carrier in between the end of each line sync and the picture signal. The actual frequency of the colour burst reference signal has to be quite high, there being nearly 300 cycles per picture line.

COLOUR SIGNAL

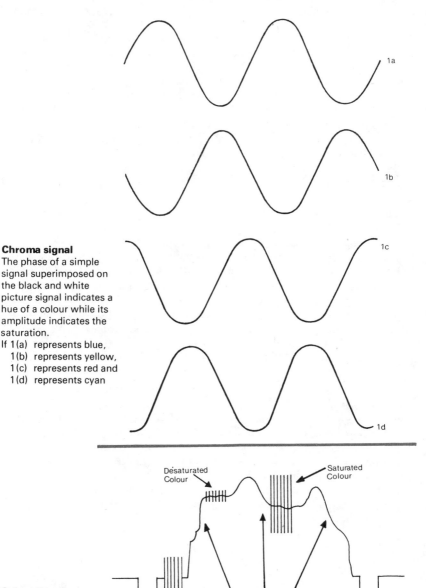

1a

1b

1c

1d

Chroma signal
The phase of a simple signal superimposed on the black and white picture signal indicates a hue of a colour while its amplitude indicates the saturation.

If 1(a) represents blue,
1(b) represents yellow,
1(c) represents red and
1(d) represents cyan

Desaturated Colour

Saturated Colour

Periods of Grey

Colour burst
The reference against which phase is taken is the colour burst.

Colour Burst

41

Tape and Heads

The choice of magnetic materials for tape and heads gives insight into the recording process. When current is passed through a coil wound round it, a bar of magnetic material becomes magnetized. There is said to be a magnetic flux in the bar which increases with the current. If the current is cut off the bar retains some magnetism. Magnetic materials are classified by the magnitude of these effects. Those which are strong magnets while the current flows but retain little magnetism are said to be magnetically soft – a term unrelated to physical softness. Materials which retain a high proportion of their magnetism, even though they may not make particularly strong electro-magnets, are said to be hard.

Tape coatings
Magnetic tape consists of a backing about .001 in. thick coated with a hard magnetic material suspended in a binder about .0004 in. thick. The magnetic material must be magnetically hard so as to retain as much magnetic flux as possible. A particular crystalline form of ferric oxide was almost universally used but chromium dioxide and ferric oxide doped with cobalt are now common. These materials are physically hard and can be used for higher bandwidth signals and give improved signal to noise ratios. The video tape widths available are:
 2 inch Quadruplex broadcast
 1 inch Helical CCTV
 $\frac{1}{2}$ inch Helical CCTV

Head construction
A head for record or replay consists of a ring of magnetically soft material with a narrow gap filled with non magnetic material. A coil is wound on the ring which becomes magnetized when signal currents are fed into the coil. The tape is made to bridge the gap, and magnetic flux in passing round the ring finds it easier to pass through the tape coating, thus magnetizing it, rather than across the non magnetic gap. It is necessary for the head material to be magnetically soft to avoid magnetizing the tape after signal currents have ceased.

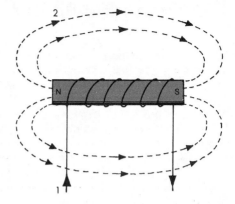

Electromagnetism

If current (1) is passed through a coil wound on a bar of magnetic material the bar is magnetised. The flux lines (2) indicate the presence of the magnetic effect.

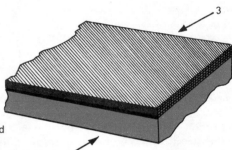

Magnetic tape

The magnetic material is suspended in a binder (3) and coated on to a suitable backing (4).

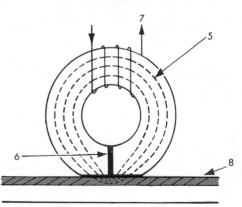

Heads

Magnetic flux (5) induced in the iron, by signal current (7) fed into the coil, passes more easily through the tape coating (8) than the non magnetic gap (6).

Recording the Sound Signal

A closer examination is now necessary of the recording process in which magnetic flux, set up in the record head by the amplified input signal, passes through the tape and magnetizes it. As the signal is a.c. the direction of flux induced in the tape alternates, and so the recorded signal appears on the tape as a chain of bar magnets. Flux reversals increase in number per second with signal frequency so the bar magnets shorten. However, if we increase the tape speed then, for a given frequency, the bar magnets lengthen.

Non linear characteristics of tape coating
In common with all magnetic materials the flux density produced on the tape does not increase in direct proportion to the signal current. To begin with, small currents produce hardly any flux but beyond a certain point the rate at which flux increases with current is considerable. An unfortunate consequence of this is that the waveshape of an audio signal is changed and it is said to be harmonically distorted.

Use of bias currents
Harmonic distortion can be avoided by superimposing the signal to be recorded on to a high frequency a.c. bias. The process confines the signal (as opposed to the bias) excursions to the straighter parts of characteristic. The magnitude of the bias current must be chosen with care. Too little will not eliminate the distortion and too much takes signal excursions into the saturation region which also gives rise to distortion. As the signal is now deviated from the lower part of the characteristic we also obtain a larger output signal for a given audio input and a reduction in the relative noise off the tape. Careful adjustment of bias gives a suitable compromise between output level, noise and harmonic distortion.

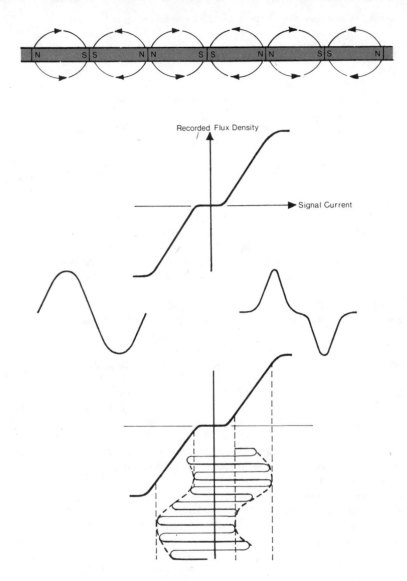

RECORDING SOUND

Record tape (top)
When an alternating signal is recorded on tape the magnetic pattern is a chain of bar magnets.

Magnetic characteristic of tape (centre)
The relationship between the signal current which causes the magnetising effect and the flux produced on the tape is not linear. Consequently, if we attempt to record signals directly they become harmonically distorted.

Bias (bottom)
The non linearity can be avoided by superimposing the signal to be recorded on top of a high frequency bias.

Replay and Erasure

To replay the recorded tape, it is passed over a head similar to the record head. Now the magnetic flux originates from the tape. As a piece of tape bridges the head-gap, the magnetic flux at that point passes round the head and induces a signal in the coil.

To induce an electric current or signal it is necessary for the magnetic flux responsible to be continuously changing. As the original recorded frequency increases, the resultant recorded magnetic pattern – our 'bar magnets' – on the tape becomes so short that a pair end to end are equal to the head gap length. When this happens, the flux is self-neutralising, and there is no output signal. It follows from this that the higher the tape speed used, the higher the maximum frequency the system can record and replay. Again, high frequency response is improved as the replay gap is shortened but there are practical limits.

Erasure

Before recording on tape, any previous signal must be erased. The process is somewhat similar to the demagnetization of a watch. We have seen (page 44) that beyond a certain value of signal current, the tape saturates. To erase the tape, therefore, it is passed over an erase (wipe) head with a wide gap fed with sufficient current to saturate the tape. The current is alternating and usually derived from the same oscillator as the bias. In the time a piece of tape takes to cross the head-gap, it undergoes several cycles of magnetization. The magnetic flux is strongest in the middle of the gap and as the tape leaves this point the cycles of magnetization become progressively weaker, eventually leaving the tape wiped clean of magnetization.

Head sequence

For a sound recorder the tape passes the heads in the obvious sequence – erase; record; replay. Amplifiers are necessary (a) to amplify the audio signal we want to record, and so provide enough current to magnetize the tape and (b) to amplify the tiny reproduced signal coming off the replay head. Separate record and replay heads are not always provided; in which case the dual-purpose record/replay head must be switched into whichever mode is required. For a video recorder it is necessary to use the same head for recording and replaying sound, otherwise the sound and its associated picture would not be in synchronism. One would be fractionally ahead of the other.

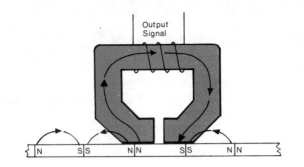

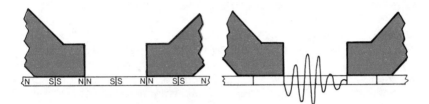

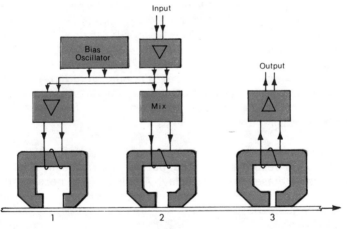

ERASURE AND REPLAY

Replay process

On replay, flux from the tape passes round the head and produces an output signal in the coil.

Extinction frequency (left centre)

When two recorded bar magnets equal the length of the replay head gap there will be no output signal.

Erasure (right centre)

During the erase process each element of tape is subject to many cycles of magnetisation.

Tape deck layout

For a sound recorder with separate record and replay heads the sequence in which the tape passes the heads is erase (1), record (2), replay (3).

Increasing Head to Tape Speed

Video signals are difficult to record because of high frequencies required for good picture quality. Two observations of particular importance have been made. One is that for a given speed the recorded bar magnets shorten as the signal frequency rises. The other is that when a pair of bar magnets are equal in length to the replay head gap the output falls to zero. Apart from these considerations there is a minimum length of recorded bar magnet which is limited by the tape coating. Using normal tape speeds and reducing the head gap length to the minimum practicable the highest frequencies available from sound tape recorders are not nearly adequate for video.

Moving the heads

The problem is solved by increasing the effective speed at which the tape passes the heads, thereby increasing the lengths of recorded bar magnets. The obvious way of doing this is to speed up the tape. However, for the speed required this was never achieved with satisfactory stability and anyway it is wasteful of tape. The universal method for video recording is to move the heads past the tape. In this way head to tape speeds of over 1000 in/sec have been achieved with good stability. Mechanical details of various types of recorder will be considered later but the principle produces the required result.

As is so often the case, the solution of one problem gives rise to another. Having recorded the tape, it is now more difficult to ensure that on replay the head accurately follows the recorded tracks but this will be dealt with when considering servo systems (pages 64 and 66).

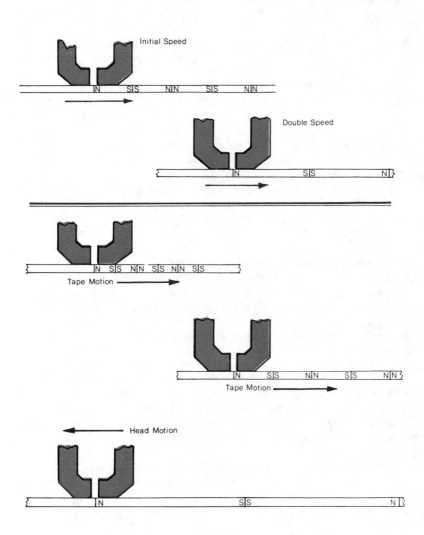

Initial Speed

Double Speed

Tape Motion ⟶

Tape Motion ⟶

Head Motion ⟵

INCREASING HEAD TO TAPE SPEED

Tape movement
Bar magnet length increases with tape speed at a given frequency.

Head movement
High head to tape speeds are achieved by fast movement of the head while
keeping the tape at normal speed.

The ingenious solution to the octave problem is to frequency modulate the signal before recording it.

Frequency Modulation

A replay head produces an output signal only if the magnetic flux in it is changing, and the faster it changes the greater the signal. In frequency terms this means that if the replay head and the head to tape speed are chosen to give an adequate signal at the top of the video band, then for every octave below this (i.e. halving of frequency) the signal voltage is halved. Taking the lowest frequency at which good reproduction is required as 25 Hz for both sound and vision, video requires, in terms of octaves, about 18 compared with 10 for sound. The implication of this is that at the low video frequencies the signal is so weak as to be unusable.

The approach to this problem is to modulate the signal, which involves translating it to a different frequency band. A simple (but not very practical) example would be to translate the signal from, nominally 0 to 5 MHz to 5 to 10 MHz, which is only 1 octave.

Overcoming head/tape contact problems

It is important in any tape machine to maintain a good contact between tape and heads. If contact is poor the signal level, both recorded and replayed, will fluctuate and result in noisy reproduction. With the high head-to-tape speeds used in video recording such contact fluctuations are inevitable. Fortunately it is possible to compensate for this varying pick-up, and to suppress the noise, by using a technique known as frequency modulation.

To begin with we generate a high frequency signal called the carrier. This carrier is to be frequency modulated by the signal to be recorded. It is lower in frequency than the carrier and it makes the carrier increase in frequency when it goes positive and fall when it goes negative. The change of carrier frequency increases with the size of the modulating signal.

If the modulating signal is video, it is important to realize that video voltage levels are represented by certain frequencies. For example, in one type of broadcast machine the values are:-
Sync tip 4.3 MHz
Black level 5 MHz
White level 6.3 MHz
and in setting up the machine it is important to fix these values accurately before recording the modulated signal (see page 126).

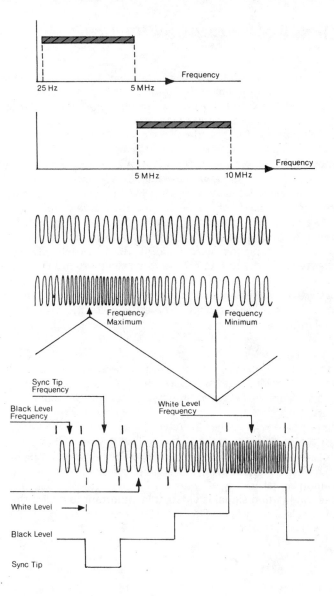

FREQUENCY MODULATION

Reducing the number of octaves
Translating the video signal to a higher frequency band reduces the number of octaves it occupies.

Frequency modulation (FM)
When a carrier is frequency modulated its frequency increases as the signal (modulating) voltage rises (say positively), and decreases as the signal goes more negative. If the modulating voltage is video the FM signal has frequencies corresponding to video signal voltage levels.

51

Helical Scan: Omega Wrap

Helical scan machines are cheaper than quadruplex. They have fewer heads and therefore simpler electronics. The head to tape speeds are lower and the track widths narrower and therefore they use less tape. The consequences are more noise, and a lower bandwidth which results in pictures of poorer definition, but the quality is regarded as being satisfactory for CCTV purposes.

Although there are many different types of helical recorder there are only three basic configurations. The omega wrap machine has only one record/replay video head. It is mounted on a wheel (much larger than that of a quadruplex machine) which rotates inside a stationary drum. There is a slit around the drum which effectively divides it into two sections and the head protrudes through the slit. The tape is wrapped almost 360° around the drum to form the Greek letter Ω. From the front the tape will be seen to climb in its wrap around the drum thus forming a helix of not quite one turn. Single headed machines use one-inch tape. The head rotates at 50 revs/sec thereby recording one TV field in each revolution. The tape is pulled at a constant speed so that it slides over the drum.

Longitudinal tracks

With the vertical position of the head halfway up the drum and the tape overlapped the head will not scan the top and bottom edges of the tape so room is left for longitudinal tracks such as sound.

Drop out

When the head crosses the gap between the end of one track and the start of the next a few lines of video are not recorded – there is said to be a drop-out. Recorders are designed for tracks to begin in the field sync period so that the last few lines of the picture are missing.

A

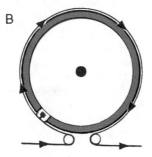

B

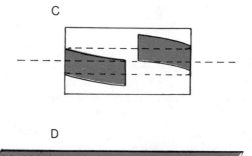

C

D

HELICAL SCAN: OMEGA WRAP

A, The heads are mounted on a rotating wheel inside a fixed drum. B, The head protrudes through a slit in the drum and scans the tape. C, The tape slides round the drum in a helical path. D, The tracks imposed on the tape are in a slanting pattern. The geometry of the arrangement shows that there are no video tracks at the top and bottom edges of the tape of omega wrap, and the video occurring when the head crosses the gap between tracks is not recorded.

Helical Scan: Alpha Wrap

For this type of machine the arrangement of a single head mounted on a wheel rotating inside a stationary drum is used again. However from the top view of a head assembly, we can see that the tape is wrapped a full 360° around the drum like the Greek letter α. Looking at the front view we can see the difference made to a tape recorded with omega or alpha wrap. In the omega wrap there can be an overlap, that is to say, the top edge of the tape at the beginning of the wrap can be higher than the bottom edge at the end. This has the advantage of leaving the tape edge free for audio etc but produces a drop-out. For the alpha wrap there is no overlap because the top edge of the tape at the beginning of the wrap must be lower than the bottom edge at the end for a full 360° wrap. The video scans are as shown opposite and the drop-out is about 2 lines. However there is no blank tape left for audio.

Drop out versus sound quality
There are two approaches to this problem. One is to wipe an edge to create space for sound but here there must be a compromise between a narrow and therefore poor quality audio track with small picture drop out against good quality sound and a large drop out. The alternative is to record sound upstream i.e. before the video. Video is then recorded on top of sound, producing a 50 Hz field frequency interfering signal on sound (rather like mains hum). On playback this signal can be reduced by an electrical filter but audio bass frequencies are also affected.

A

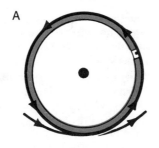

B

C

HELICAL SCAN: ALPHA WRAP

The video tracks scan right across the tape so drop-out must be increased to
make room for sound, or sound recorded on top of video. A, Basic alpha (a) wrap.
B, Front view of alpha wrap. C, Video tracks across the full tape width.

Helical Scan: Two Headed Wrap

By contrast with single headed machines drop-outs are avoidable in two headed machines. The head drum assembly is similar to those on the other helical recorders but with two heads on the rotating wheel spaced from one another by 180°. On 'record' the modulated video is fed to both heads simultaneously and if the angle of wrap is slightly greater than 180°, some of the video is recorded twice. Further, if the tape climb is less than the tape width, the tape edges are left free for longitudinal tracks and there is no drop out.

Halving the head rotations
To record one complete TV field on each video track the head wheel rotation must be 25 revs/sec. i.e. half that of the single headed machines. To achieve the same head to tape speed as on a single headed machine it would be necessary to double the drum diameter.

Halving the tape width
With a nominal 180° wrap it is easier to get good contact between head and tape than with the 360° wrap, and half-inch tape is usual compared with one-inch for the single headed machines. However the line-up of the heads with respect to one another is critical. Further the electronics become more complicated if the manufacturer chooses to include a switcher so that on replay a signal is taken only from the head scanning the tape.

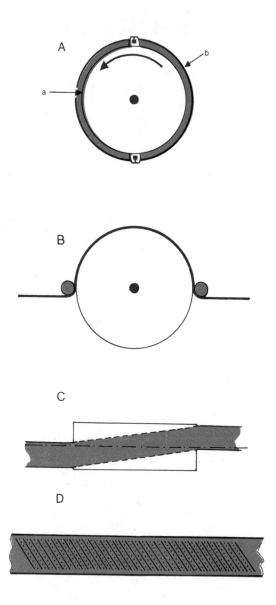

HELICAL SCAN: TWO-HEADED WRAP

With two heads there is room at the tape edges for audio. There need be no drop out if the wrap is more than 180° because head 2 can begin recording a track before head 1 leaves the tape i.e. there's an overlap. A, Rotating wheel (aa) inside fixed drum (b). B, Tape wrap greater than 180°. C, Tape climb less than tape width. D, Head 1 tracks indicated by continuous line, head 2 tracks dotted.

Transverse Scan (Quadruplex)

In this type of recorder there are four video record/replay heads mounted on a wheel at 90° with respect to one another. Different manufacturers of quadruplex machines have standardised on certain dimensions so it is reasonable to quote certain figures. The head wheel is nominally 2in. in diameter and rotates at 250 revs/sec to give a peripheral head speed of 1570 ips. The 2-in wide tape is shaped into a guide by a vacuum. The head wheel is positioned so that the heads are pressed into the tape coating and as the wheel rotates the heads scan across the tape transversely. At the same time the tape is being pulled past the head wheel at a nominal speed of 15 ips so the heads produce tracks across the tape with a slight slant. Each track is shorter than a helical recorder track and with a higher head to tape speed there is much less playing time, in fact not quite 20 lines compared with a whole field of $312\frac{1}{2}$ lines on a helical machine.

Overlap

We can see from the diagram that at certain times two heads are scanning the tape simultaneously. On record, modulated video is fed to all four heads all the time so an overlap is recorded, leaving room for longitudinal tracks. Again the output of the machine must be switched from one head to the next on replay but with less than 20 TV lines per scan it is evident that switching must now be carried out during line blanking rather than field blanking.

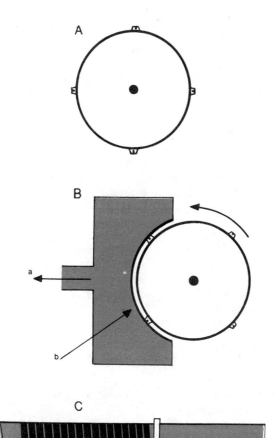

TRANSVERSE SCAN

Quadruplex

The overlap precludes any drop-out and is large enough to leave room for audio tracks. A, quadruplex head wheel. B, tape guide (b), heads and vacuum (a).

Video track pattern

If the tape were not moving the recorded tracks would be perpendicular to the edge of the tape. The tape movement gives the tracks, C, a slight slant.

Cassettes

The types of recorder described can be designed as reel-to-reel arrangements where the operator laces up the tape and winds the end of the tape on to a take-up reel; or as a cassette type where the operator simply plugs in a cassette and pushes a button.

The cassette can hold the tape in three different ways:

1. A conventional enclosed reel with a stiff leader to facilitate the self-lacing action of the recorder.
2. A feed spool and a take-up spool mounted side by side enclosed in a single package. Very similar to an audio cassette.
3. A feed spool and a take-up spool mounted on top of each other enclosed in a single package.

In the helical field all three forms exist, which adds further to the standardization problems. Types 1 and 2 are very popular among the American and Japanese models, some even producing tapes to the EIAJ standard, while 3 is the Phillips VCR standard.

In the quadruplex standard, type 2 is exclusively used.

Package 1 is obviously more compact but suffers from the disadvantage of having to be rewound before removal from the machine. The other two types can be stopped half way through a programme, removed, returned at a later date and continued from the place left off. Tape cassettes have two main advantages over reel-to-reel recorders:

1. They are simple to use.
2. They protect the most vulnerable part of the recorder, the tape itself.

The only disadvantage is that the cassette is more bulky and more expensive to manufacture.

For this reason cassettes have started in the two extremes of the market, i.e. the broadcast field where size and cost are secondary factors, and in the lower priced domestic market where economies can be made by accepting a lower standard and thus smaller volume of tape.

The lacing procedure varies from machine to machine but in all cases the tape has to be pulled out from the cassette and made to pass around the video drum scanner and past the other heads.

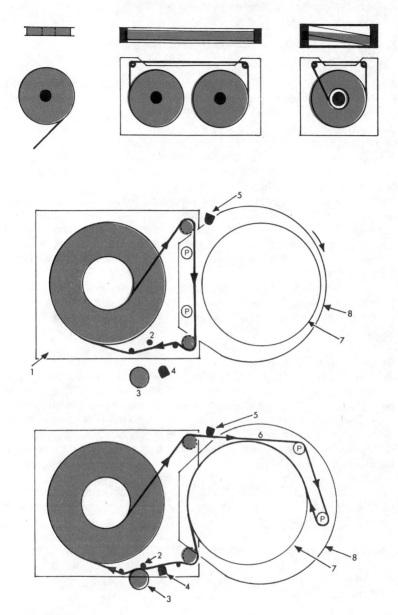

THE FORM OF CASSETTE

Types

The types of cassette available are those with a single spool and a stiff leader, two spools side by side or two spools stacked vertically.

Method of lace up (VCR)

When the cassette (1) is inserted, two pins on the rotating platform (8) pull the tape out (6) round the video drum (7) and past the erase head (5) audio head (4), capstan (2) and pinch roller (3).

Electronics: The Signal System

Before the video signal is recorded it must be frequency modulated and then amplified to provide sufficient current to drive the record heads. With video translated into a high frequency modulated signal the harmonic distortion encountered because of the non linear magnetic characteristic of the tape (see page 44) distortion encountered is of no consequence, so bias is not required and the optimum value of record current is that which causes the peaks of the modulated video to take the tape just into saturation.

The modulated signal must be amplified before being fed to the heads. Apart from amplification there may be frequency correcting networks (equalizers) to compensate for high frequency losses in the record process. Some machines have a separate amplifier to drive each head so that the gains may be adjusted separately to allow for different head efficiencies.

In the simplest machines the replay signal system is like that on record but reversed. However some multi-headed machines have a switcher which allows only the signal from the head scanning the tape to get through to the output.

Electronics to electronics

In a sound tape recorder it is a relatively simple matter to provide separate record and replay heads so that when recording, the tape can be replayed a fraction of a second later thus guaranteeing a successful take. Such a facility is uneconomic for video so the recording must be made "blind" so to speak and later replayed to check it. However, during the record process a considerable part of the signal system can be checked if the modulator output is not only connected to the record amplifier but also to the demodulator, a signal routing called Electronics to Electronics (E-E). If the demodulator output is a satisfactory video then at least we can say the modulator is working properly.

One difficulty with rotating heads is that of connecting the signal into them on recording and taking it from them on replay. The most common method is to use a rotating transformer which has a stationary coil connected to the amplifier and a head coil which rotates with the head wheel.

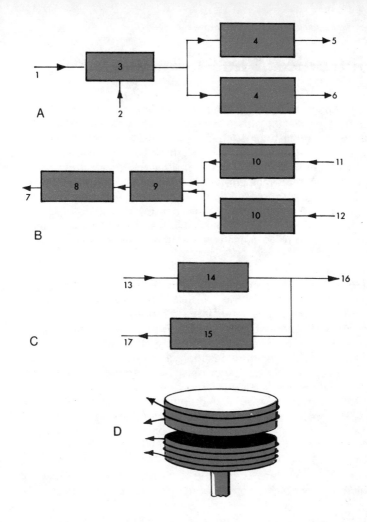

ELECTRONICS: THE SIGNAL SYSTEM

Record mode

A, The video (1) is frequency modulated (3) on to the carrier (2) and then
amplified (4) before being fed to the heads (5, 6).

Replay mode

B, This is the reverse of the record process. The signal from the heads (11, 12) is
amplified (10) and then, on some multi-headed machines, passes to a switcher
(9) which allows only the signal from the head scanning the tape into the
demodulator (8) and so to the output (7).

Electronics to electronics (E-E)

C, On record the modulator (14) performance can be checked by feeding its
output (16) into the demodulator (15) and monitoring the result (17).

Rotating transformer

D, One method of feeding a signal to or from a rotating head is to have a rotating
coil feeding the heads on the head shaft and a nearby stationary coil connected
to the signal chain. The two coils make up a transformer.

63

Electronics: Record Servos

Having chosen to use a rotating head to record video a method must be found to make the head(s) accurately scan the recorded tracks on replay. Servo mechanisms (usually just called servos) are used. These are electric motors whose drive shaft positions are controlled by a reference input signal. We shall consider the servos used on single-headed helical machines but two-headed and quadruplex servos work on similar principles. There are two servos involved, one to control the head rotation, i.e. the drum scanner control, and the other to control the capstan motor, i.e. the rate at which tape is pulled past the heads. It is as well to consider these servos first on record then on replay.

Tach pulse

To begin with a drum scanner tachometer (tach) pulse is generated, i.e. a signal consisting of one pulse for each revolution of the head. One common method of generating this signal is illustrated opposite. Every time the magnet passes the coil a pulse is induced in it. The primary object is to make the drum rotate at the field frequency of the signal being recorded thus ensuring that each track comprises one complete field. A field frequency pulse is separated from the video and fed into a comparator as a reference. Also fed in is the tachometer signal. The comparator gives an output signal when its two inputs are not synchronised. This output alters the drum motor rotation and hence the tachometer signal until it is synchronised to the reference.

Control track

A second requirement is to time the drop-out on a single-headed machine to occur at the bottom of the picture. The position of the drop-out with respect to field sync can be controlled by adjusting the time the tach pulse is delayed. Finally, to lay the foundation for the replay mode, the tach pulse is recorded on the edge of the tape by a conventional stationary head. This is called the control track and is a record of the position of the head drum with respect to the video tracks while the recording is being made. It is analogous to the sprocket holes on a film.

The other important servo, controls the capstan motor. The speed of this determines the spacing between video tracks. On record a capstan tachometer may be compared with field frequency to control the capstan speed. The important point to see now is that the control track signal and track spacing are both fixed by the same reference, i.e. field frequency.

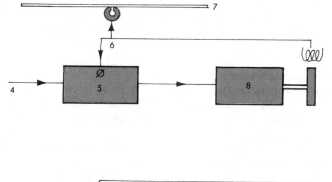

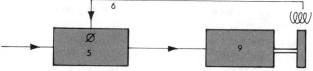

ELECTRONICS: RECORD SERVOS

Tach pulse generator
A magnet (3) fixed to a disc mounted on the head shaft (1) induces a pulse in the coil (2) every time it goes past it.

Head servo—record mode
By comparing (5) the head tach pulse (6) with field sync (4) and adjusting the head motor speed (8) until the two pulses are synchronised the head drum rotation is locked to field sync. The head tach pulse is recorded on the control track (7) and used on replay.

Capstan servo—record mode
In a similar manner the capstan motor (9) is also locked to field sync by comparing the capstan tach pulse.

Electronics: Replay Servos

There are two basically different replay servo arrangements. The simpler one controls the head drum scanner while a more complex, and, at the same time, a better method controls both drum scanner and capstan. For the first method the capstan is driven from the a.c. mains on replay whereas on record it is locked to field frequency. The result is that tracks pass the heads at the mains frequency which, although nominally the same as field frequency, may easily vary by 4%.

All that is now required is that the heads makes one complete revolution for each field replayed. The reference is the control track made on record, and when the head drum tach pulse is compared with this, any discrepancy between the two alters the head drum rotation. The result then is that no matter what the mains frequency, every pulse off the control track makes the head scan one track.

Head and capstan servo
The more complex system is servo control of both head and capstan. The drum scanner is now locked to an external reference which can either be field frequency, derived from a local source of video, or the mains. The process of capstan control is not so easy to understand. The capstan speed is correct if control track pulses are passing the control track head and therefore the head drum at field frequency. Synchronism between the head drum and external reference is already being effected so if the replayed control track signal and external reference are also synchronised the capstan speed is correct. A comparator, whose inputs are field sync (or mains) and a tachometer pulse generated from the capstan motor, adjusts the capstan motor speed until it is synchronised with the external reference, i.e. field sync or mains.

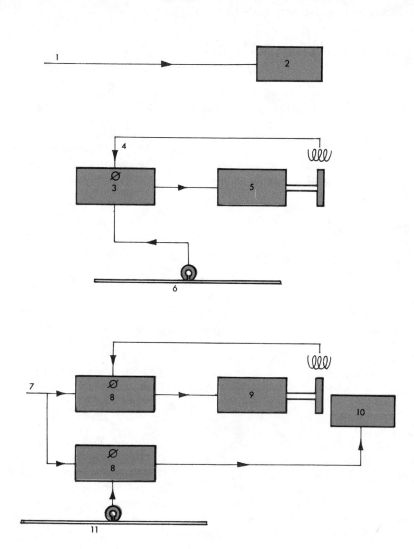

ELECTRONICS: REPLAY SERVOS

Head drum only servo
The capstan motor (2) determines the rate at which tracks pass the head and this
is controlled by the power supply (1). A comparison (3) is made between the
control track signal (6), which is a record of head drum position on record, and
the head tach signal (4). Synchronisation between the two is achieved by the
comparator output controlling the head motor speed (5).

Head and capstan servo
The external reference (7) which is power supply or field sync, controls the head
drum motor speed (9) and the capstan speed (10) through the comparators (8).
This in turn controls the rate at which tracks pass the head. The capstan speed is
correct when the control track signal (11) i.e. the record of head drum speed, and
the head drum are both locked to the reference.

Position of the Heads

The sequence with which the tape passes the heads is not the same for all machines, neither is it always inevitable for a given type of machine. However certain principles can be laid down. As with a sound tape machine the first process is to erase the tape across the width to be used for video and have a separate sound erase head to permit the recording of sound or video only. The method is to use a record head with a relatively wide gap fed with a high frequency current (see page 46).

Quadruplex
With a quadruplex machine video tracks are first recorded right across the tape. The control track is then recorded on the bottom edge, no erasure being necessary. For the high quality of sound required in broadcasting an erase head is necessary to wipe part of the overlap at the top edge of the tape clean of any interfering signals within the audio band. This is followed by a sound record/replay head and perhaps a replay head for checking sound quality during recording.

Helical
On a two-headed helical or single-headed omega wrap recorder (see pages 52 and 56) the sequence can be the same but it is not essential to have a sound erase head or even to record audio after video because the tape climb is less than the tape width so the edges are left free for the audio and control tracks.

For alpha wrap (see page 54) the video scan is across the whole tape width with no overlap. According to the head sequence chosen drop-out time is large or an interfering video signal is recorded on top of sound. Whichever head sequence is chosen, video and its corresponding sound are separated by the distance between the heads. If mechanical editing is contemplated it is an advantage for the heads to be as close together as practicable.

HEAD POSITIONS

Quadruplex head sequence
Video erase (1) precedes video record (2) and control track heads (3). Sound
erase (4), record (5) and replay (6) are in the usual sound tape deck sequence.

Alpha wrap head sequence
This layout has only one full tape width erase head (7) and a sound record/replay
head (8) before video (9) and control track heads (10). The arrangement
minimises drop out at the expense of sound quality.

Tape Formats: Quadruplex

The tape format is the pattern of tracks produced on a tape by a particular machine. For quadruplex recorders certain standards have been adopted, which is useful because it permits tapes recorded on one make of machine to be replayed on another; the machines are said to be compatible. The pattern of video tracks produced before sound and control tracks are straight lines almost perpendicular to the edge of the tape. A 10 mil (1 mil = 1 thousandth of an inch) wide head obviously produces 10 mil wide tracks and a simple calculation involving the rate of head rotation and tape speed would reveal a spacing between the tracks about half as wide. The other tracks which are added after video are:

1. Main audio track at the top edge. The audio erase is a little wider than the audio record thus leaving a narrow guard band between audio and video.
2. A second audio track for cueing, producer's instructions and so forth. High quality sound is not required so the track is consequently narrower than the main audio.
3. Control track.

These last two tracks are at the bottom of the tape.

The audio playback head is $9\frac{1}{4}$ in downstream from the video which means that at any point on the tape the sound is 0.6 sec ahead of the video, a fact that creates a difficulty in editing (see page 96).

In passing it is worth noting that the field sync pulses always occur at the middle of a video track whereas a switch between heads always occurs near the end of a track and will not disturb field synchronism. It also simplifies the joining of two sections of tape for a mechanical edit.

QUADRUPLEX TAPE FORMAT

This format has been designed for the high quality of reproduction required to meet broadcasting standards. Consequently there is a generous overlap which avoids a drop-out and leaves ample room for an audio track of width consistent with high fidelity and also for cue and control tracks. The ratio of video to space between tracks is approximately 2:1. 1, Main audio track. 2, Video tracks $9\frac{1}{4}$ in. upstream from audio. 3, Second audio or cue track. 4, Control track.

Tape Formats: Helical

If the head starts at the top edge of the tape, the track position slopes downward as the tape climbs. On typical two-headed machines each head records alternate tracks with sound at the top edge and control track at the bottom. With quadruplex the video tracks are virtually at right angles to the tape edge so the time relationship between sound and video is fixed. Helical tracks are almost longitudinal so the time relationship varies over a track length. However, for any recorder the sound must either be all upstream or downstream and for a two headed machine it can be either. The format for a single headed omega wrap machine is similar.

The format for an alpha wrap with sound and control track recorded upstream to minimise drop-out is shown opposite. In contrast with the other helical formats, sound and control tracks are not at the extreme edges of the tape.

Sync line up
One other feature of helical formats is that of sync line up. Throughout a video track of one field the points at which line syncs are recorded are side by side for adjacent tracks. Its advantages lie in the processes of stop and slow motion and in minimising the consequences of mis-tracking. If a head is scanning over two tracks instead of one there is effectively only one set of line sync pulses and therefore no picture break-up.

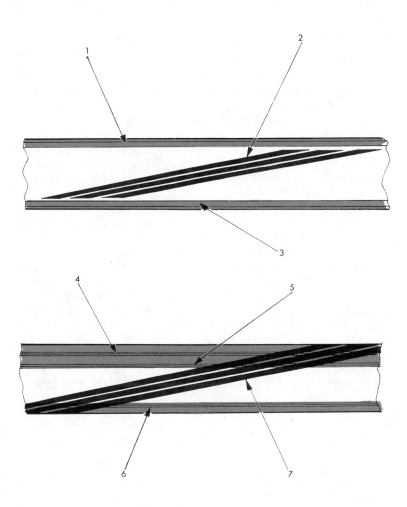

HELICAL FORMAT

Two headed (or omega) wrap
1, Control and second audio tracks. 2, Video tracks. 3, Main video.

Alpha wrap
4, Second audio track. 5, Control track. 6, Main audio track. 7, Video tracks.
Sound and control tracks for two-headed or omega-wrap formats must be near
the tape edges to minimise overlap and maximise the space available for video
tracks. On alpha wrap when video is recorded on top of sound and control tracks
they do not have to be near the tape edges.

Tracking

Servos are necessary to make sure that on replay, the video head(s) pass accurately along the recorded tracks and not down the guard band in between (page 64). If the head does not track properly the signal coming off the tape is weak and produces a noisy picture.

When the machine is switched to replay mode the servos make the head track in the same relative position with respect to the recorded tracks and guard bands between one scan and the next but it is difficult to design a machine where tracking is automatically correct. It can be affected, for example, if the amount by which the length of tape between the control track head and video head stretches is not the same for all tapes.

It is therefore necessary to provide a tracking control which must be adjusted when beginning a replay to make the video head track properly. The control varies the delay of the drum scanner tach pulse being fed into the head servo comparator. Comparison with the head servo record diagram (page 65) reveals that it is the same mechanism as that for positioning the drop-out on record. The tach pulse frequency is not altered once an adjustment has been made so once accurate tracking has been established the control track and head tach signals remain locked together to maintain consistent tracking. An alternative method is to adjust a delay in the path of the signal coming off the control track head. The knob which controls tracking may be labelled *tracking or control track phasing.*

If a waveform monitor is not available the adjustment should be made while looking at the reproduced picture, minimum noise on the picture indicating accurate tracking. When the control is being adjusted it takes the servos a little time to react, so having made a small adjustment the operator should pause for a second or two to see the effect.

If a waveform monitor is available, tracking is accurate when the modulated signal coming off the tape, usually monitored at the switcher output, is maximum. It must be remembered that this signal is frequency modulated so its amplitude makes no difference to the demodulated video amplitude but only to the noise on it.

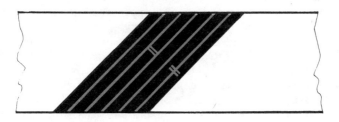

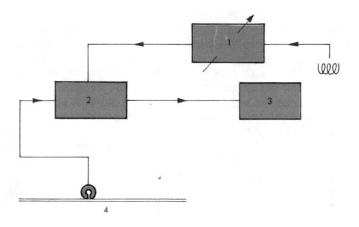

TRACKING REQUIREMENTS

Tracking

On replay the video head should pass along the recorded track as on the left and not down the guard band as on the right.

Tracking control

Tracking can be adjusted by inserting an adjustable delay (1) between the head tach signal and the comparator (2) which controls the head drum motor speed (3). The other comparator input is the control track signal (4).

Tape Tension

Between the feed and take-up spools the tape is kept in tension so as to hold it on a consistent path. The tape speed is controlled by the capstan, thereby maintaining the forward tension. The back tension is either provided by a brake on the feed spool which the capstan has to pull against or by a motor which tries to turn the feed spool in the opposite direction to which it is being pulled.

On a quadruplex machine the control of tension is not critical because a longitudinal stretching of the tape makes little difference to the length of a track across the tape. For a helical machine, correct tensioning is essential. The main requirement is that the length of tape stretched around the drum should be the same on playback as on record. If, for example the tape stretch is greater, then as the head progressses through a TV field, line syncs occur progressively later relative to the last field sync. When the head switches to the next track the field sync occurs before the corresponding line sync and on certain types of monitor this produces a 'hook' on the picture.

Tensioning is one of the factors which makes compatibility difficult. Any difference in tension around the head drum is probably only the same on record and replay for an individual machine. However, even restricting the operation to one machine, differences can occur between record and replay. The ideal drum material offers no friction to the sliding of the tape. Satin chrome approaches this ideal if it is kept clean but any build up of tape coating on the drum increases friction. The drum should therefore always be cleaned before lacing up the tape. Tension changes due to the increasing amount of tape on the take up spool must be eliminated in the machine design.

Tension servos
A tension servo keeps the tension correct in spite of such factors as oxide build up and spool loading. The tape generally passes round a tension arm mounted on a spring, if the tension varies for any reason the arm position varies the power fed to the take-up spool. When the machine is being set for replay the spring tension can be adjusted to eliminate 'hooking'.

On more expensive recorders the process is automatic. The fact that line syncs on adjacent tracks should line up is used. If on switching from one track to the next there is a timing discrepancy, the servo system senses the error and adjusts the tensions.

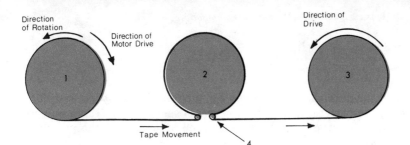

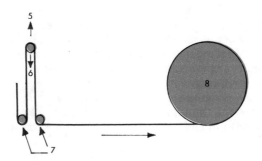

TAPE TENSION

Methods

As an alternative to providing a brake the tape can be tensioned by making the capstan pull the tape against the spool drives. 1, Feed spool. 2, Head drum. 3, Take-up spool. 4, Head drum.

Hook on picture

Incorrect tension on playback produces a hook on the reproduced picture.

Tension servo

Tension is applied by a sprung arm pulling the tape between the fixed guides (7) on its travel to the take up spool (8). Movement of the sprung arm (5, 6) affects take up spool power.

Typical Deck Layouts

Deck layouts vary, sometimes for fundamental reasons, sometimes because of designers' whims. A few observations on some particular decks will leave little to be said on all others. The large measure of agreement on quadruplex tape formats permits us to describe one deck as being typical. Apart from setting the tape tension correctly when running, the tension arms also keep it bent like a spring so that when the machine starts the tape does not snatch. Air may be blown through the guide so that the tape coating, instead of rubbing against it, effectively floats on an air cushion. Alternatively the guide may be a roller. The head tach signal can be generated by a tone wheel or a magnet rotating on a disc as previously described (see page 64). The video lead to and from the head is by slip-rings and brushes as an alternative to rotating transformers. To pull the tape at the correct speed it is squeezed against the capstan shaft by a flexible pinch roller. When the machine is not in record or replay modes the roller is held away from the capstan and tape movement is controlled by the spool motors. A counter-roller steps the counter on to time the tape to tenths of a second.

Helical decks
By contrast helical machines are many and various. The tape can either rise or fall in passing round the drum. There are usually tape guides at the beginning and end of the wrap and sometimes tape guide pins are fitted on the drum, these features being provided to keep the wrap accurate and consistent. On some helical machines the tach signals are generated by shining a lamp on to a disc fixed to the appropriate shaft (i.e. head or capstan). There are holes in the disc and as the holes pass the lamp the light shines through them on to a photo transistor which then gives an output pulse.

Apart from the wraps themselves many features of omega and alpha decks are similar although the alpha wrap is the simpler of the two.

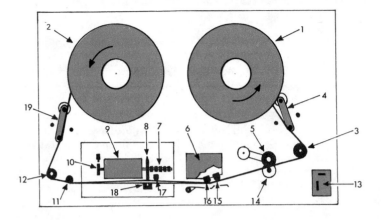

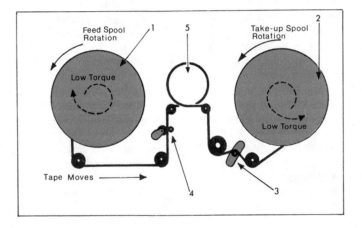

DECK LAYOUTS

Quadruplex deck
1, Take-up spool. 2, Feed spool. 3, Counter roller. 4, 19, Tension arms. 5, Pinch roller. 8, Head wheel. 9, Head motor. 10, Head tachometer. 11, Master erase head. 12, Air guide. 13, Tape timer. 14, Capstan shaft. 15, Audio and cue record/replay heads. 16, Audio and cue erase heads.

Alpha wrap deck
1, Take-up spool. 2, Feed spool. 3, Tension arm. 4, Capstan. 5, Alpha wrap around head drum.

79

Standards and Compatibility

European standards for quadruplex recorders are laid down by C.C.I.R. recommendations 469.

This enables various manufacturers to make machines which produce compatible tapes, i.e. a tape recorded on one machine can be played on another.

The format, introduced in 1956, gives excellent interchange as the video tracks are short and wide with a generous guard band. With improvements in tape control, the format has been criticised for being wasteful (over a third of the tape area not being used).

With helical machines there is a multitude of standards. Most manufacturers, not all, guarantee compatibility between their own models but only on the $\frac{1}{2}$ in standard is there any agreement between manufacturers. A standard is normally specified in terms of the tape format and the following standards are the most common.

EIAJ Standard half-inch (two-headed). This format is used on reel-to-reel, cassettes and cartridge machines, mainly of Japanese and US manufacture. It was designed for use with high energy tape which allows the slower scanning speed, smaller diameter drum and shorter video track lengths to other one inch helical formats.

Philips VCR (two-headed). This format is very popular in Europe although it is made under licence throughout the world by various companies. It is always in cassette form. It was also designed for high energy tape and is unusual in so far as the head and tape movement is in the same direction.

Sony Umatic (two-headed). A low-priced cassette system using $\frac{3}{4}$-in wide tape giving two audio tracks and an improved performance over the $\frac{1}{2}$-in helicals.

Ampex omega wrap one-inch (one-headed). A medium to high priced range of helical recorders with models suitable for basic record/replay, CCTV master recording and colour. It has one of the longest video track lengths of all formats.

The IVC alpha wrap one-inch (one-headed). A similar range of models as Ampex with prices to match. Although it was introduced later it has become a very popular format. It is interesting to note that the video tracks go from edge to edge and the audio tracks are on top of the video. This reduces the amount of tape area wasted.

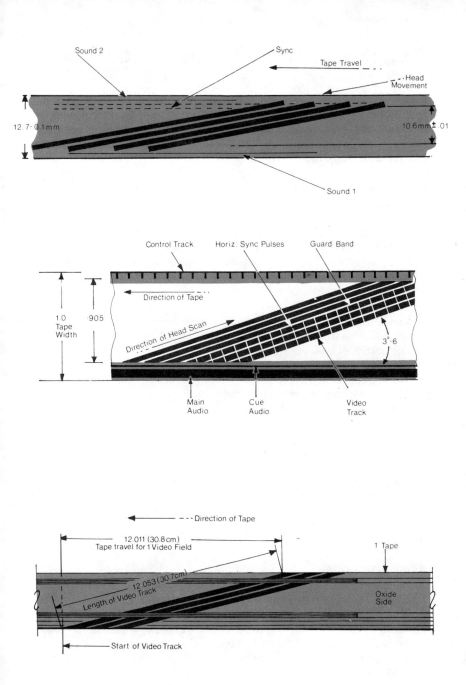

TYPES OF HELICAL FORMAT

Philips VCR: a two headed wrap. Ampex 1 inch: an omega wrap. IVC 1 inch: an alpha wrap (Note the audio tracks over the video tracks.)

Basic Facilities and their Limitations

A basic VTR records a vision and sound signal, plays the vision back on to a monitor and the sound out to its internal loudspeaker. If more is required, the basic machine has certain limitations. For instance although the picture looks very stable on the monitor it is unlikely that it is stable enough to mix with another source.

Output capability
The basic VTR can drive up to about four monitors and one extension speaker.

If more outputs are required, extra distribution amplifiers (DAs) are needed. A vision DA and audio DA would typically have 4 to 6 outputs.

If the installation is large, a device called a processor between the VTR and VDA will ensure good clean sync pulses.

Tape copies
If several tape copies are needed, at least one machine should have the accessories to ensure the best possible playback quality.

The sort of extras required would be:
1. Drop out compensator (see page 86).
2. Burst equalizer to make the frequency response of all heads for the chroma signals the same (see page 88).
3. Time base error correctors (see page 90).
4. Processor (see page 94).

Slow motion and still frame
If the tapes are needed for analysis, such as viewing X-rays, sporting technique or security observation, slow-motion and still frame facilities are necessary. For conventional programmes however the facility is seldom used. The slow motion is not quite as good as the stop action replay as seen on broadcast television and a buyer should see it demonstrated before deciding its merit (see page 84).

Electronic editing
An electronic editor allows you to assemble separate scenes on to a tape with a clean cut between scenes (see page 100).

If your studio facilities are limited (only one camera or no mixer), an editor is essential if anything other than a simple one-shot programme is required (see pages 146, 148, 150).

An editor is also useful for removing errors and generally allows more flexibility in production.

If a machine to machine editing is envisaged, the extras to improve the quality of the playback machine should be purchased (see pages 86, 90, 94).

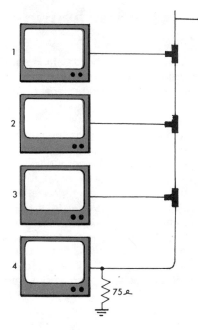

1

2

3

4

$75\,\Omega$

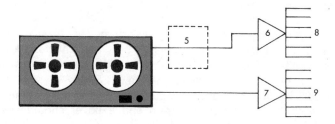

5

6

7

8

9

DISTRIBUTION OF SIGNALS

A simple arrangement
The video can drive several monitors if care is taken. The leads to monitors 1, 2, 3 from each tee-pieces should be kept short (less than one metre). *Only the last monitor (4) should be terminated in 75 ohms.*

For isolated outputs
Audio distribution amplifiers ADA (7) and video distribution amplifiers VDA (6) can be used to drive up to six loudspeaker amplifiers (9) and six video monitors (8).
The addition of a processing amplifier (5) is optional.

Accessories: Stop and Slow Motion

Stop and slow motion methods devised for helical machines are not completely satisfactory and with quadruplex systems, such techniques as have been produced are so complicated that for broadcast purposes, completely different machines recording on magnetic discs rather than tape are used.

For stop motion on helical, if the tape is stationary, the head scans across it with a slightly different angle from that of the recorded track. In the diagram opposite, for example, we see two recorded tracks with the head about to begin a scan at point A. If the tape were moving the head would complete its scan at B. Instead, with the tape stationary it arrives at C by the path shown. As the head is wider than the band between tracks it is always replaying video and sync line up allows picture synchronism to be maintained. However, in scanning over the gap the head picks up noise off the tape giving a noise band across the middle of the picture. The band can be shifted by starting the scan somewhere other than the centre of a track. An apparent slow motion is produced by running the tape below normal speed but the noise band now disturbingly drifts through the picture.

Slow motion disc

A 16-in. diameter, $5\frac{1}{2}$ lb, nickel cobalt disc is the recording medium used for stop/slow motion broadcast replay. The basic VTR method of recording is used i.e. basic head construction, frequency modulation of video and so on. The recording is made in concentric rings, not in spiral form as with a gramophone record. The disc rotates at 50 revs/sec. for a 625/50 signal thereby recording one field per track. The head is then moved in one step while a separate head records another field on the back of the disc. Each head jumps a track when it steps so that when it reaches the innermost track it can reverse direction and travel outward again by filling in the gaps. With a capacity of 450 tracks for each surface, the total of 900 tracks on a disc gives a playing time of 18 seconds on 625/50. The recording sequence prevents having to make the head assembly fly back from inner to outer track and cause a gap in the recording. Thus, with one disc the preceding 18 seconds of transmission is constantly available for immediate playback. The 36 seconds recording time provided by dual disc designs, meets most production needs.

Stop motion is obtained by continually playing back one field; slow motion by playing back each field more than once. By recording, say, every other field the normal playback gives double speed. Reversal of the head stopping sequence gives reverse motion. The playback modes available apart from normal are stop, half speed, one-fifth speed, variable speed and reverse.

84

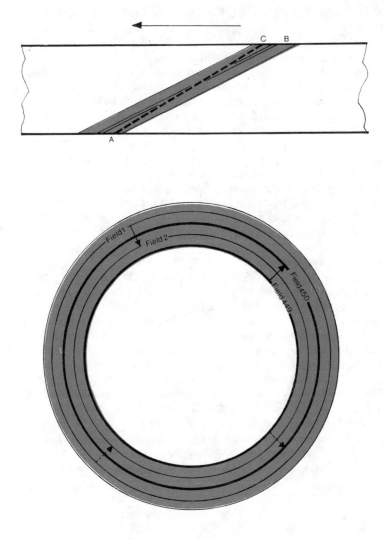

STOP AND SLOW MOTION

Helical
Stop motion on helical necessitates crossing the guard band which produces a band of noise on the picture. A-B, Head path with tape moving. A-C, Head path with tape stationary.

Slow motion disc
Each ring (not spiral as on a gramophone record) is a recording of one complete TV field.

Accessories: Drop-out Compensator

If head and tape part company during a head scan the impairment can be reduced using a drop-out compensator. So far we have used the term drop-out with reference to single-headed recorders to describe the time for which the head leaves the tape in between scans. This is predictable and steps are taken to mitigate the effect on picture. For several reasons (e.g. loose oxide particles on the tape) tape and head may also part company during a scan on any recorder. This is also called drop-out and it produces a burst of noise on picture or loss of synchronism if it mis-shapes a sync pulse.

The drop-out compensator uses the fact that most of the information in any particular TV line is the same as on the previous one. If, when a drop-out occurs we replace it by repeating the video signal of the previous line the impairment is reduced.

Detecting drop-outs

A drop-out causes a fall in the amplitude of the frequency-modulated video coming off the tape. This fall is used by an amplitude detector to operate a switch. Now, instead of feeding the signal direct to the demodulator it is taken from a 64 micro second (μs) (i.e. one TV line) delay permanently connected to the signal off the tape. The output of the delay line is what went in one line ago and as long as the drop-out continues the last good line is replayed over and over again. When the drop-out ends the detector restores the switch to normal.

Drop-out compensation for the colour system used in the UK is complicated by the fact that one of the components used to add colour to monochrome in this system is inverted on alternate lines. Thus, repeatable information is only available every other line and so the colour part of the drop-out compensator uses a two line i.e. 128 μs delay.

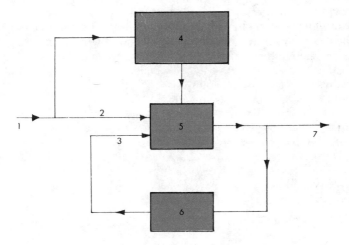

DROP-OUT COMPENSATOR

Video drop-out
When a drop-out occurs, the FM signal coming off the tape suffers a fall in amplitude.

Compensation
When a drop-out is detected a switch is operated which takes the signal output from a delay line rather than the signal off the tape. The delay is equal to the time of one line so the output is the previous line repeated rather than the one with drop-out. 1, FM signal off tape. 2, Normal input. 3, Input used during a drop-out. 4, Amplitude detector. 5, Switch. 6, 64 μs delay. 7, Output to demodulator.

Accessories: Burst Equalisation

To some extent the frequency responses of the video heads on a multi head recorder during playback are different, and compensation for these differences can be carried out automatically. The need for the signal system to include equalization, i.e. compensation, for high frequency losses has been mentioned (see page 62). Not only should the equalization make the responses substantially flat but it should also make them the same for each head. If the responses are not the same on a quadruplex recorder, 'banding' occurs i.e. horizontal bands of 15 or 16 lines standing out in contrast with one another. The effect is particularly noticeable on a colour playback because the colour signal is placed at the higher video frequencies.

Automatic equalization uses the fact that each line containing picture information has a colour burst during line blanking (see page 40). At the studio the amplitude of the colour burst is carefully controlled and if the playback equalizers are correctly matched then all colours bursts will be the same on replay. The bursts from each head are separated from the rest of the signal and fed into a storage circuit which measures their level over a number of lines. The store feeds a correcting signal to each playback equalizer, adjusting it until the demodulated bursts are all equal.

Colour Bursts

BURST EQUALISATION

Colour bursts
All colour bursts should have the same amplitude on replay.

Equaliser circuit
Each store measures the burst amplitude from a head and feeds a correcting signal to the appropriate head equaliser. 1, Head outputs. 2, Head equalisers. 3, Switcher. 4, Demodulator. 5, Video output. 6, Stores.

Accessories: Timing Error Correction

A timing error exists when there is a timing discrepancy between an external video reference signal and video off the tape. It makes the two signals non-synchronous and means that they cannot be mixed satisfactorily. To give an example of a timing error consider the diagram opposite. One of the heads is misplaced and if it plays back a tape recorded with correctly spaced heads then its tracks occur too late, and on normally straight vertical edges, produces the effect shown. If the maladjusted head were used for record only, the displacement on picture would be in the opposite direction.

Another source of timing error is incorrect positioning of the tape guide relative to the head wheel. The most careful mechanical adjustment leaves intolerable errors which are reduced electronically.

The principle of the electronic corrector, which is universal, is to pass the replayed video through a line whose delay time can be controlled. The leading edge of line sync off the tape is compared with that of a stable reference, such as a local feed of sync, and the resulting error voltage either increases or decreases the delay by the appropriate amount. Thus the correction is made only once per line and is made before the picture information on the line begins, the assumption being that any change in error between line syncs is small. Bearing in mind that there are about 20 lines in one track the assumption is reasonable.

Voltage-dependent delay
A section of the voltage-dependent delay line is shown opposite. The delay of a line increases with the values of inductance and capacitance and in this case the capacitors are varactor diodes, devices whose capacitance varies with the voltage across them. The control voltage then, varies every other capacitance and hence the delay.

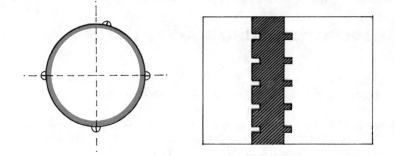

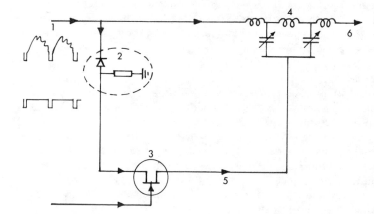

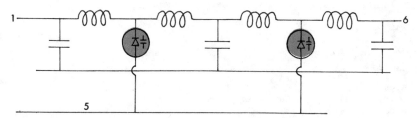

TIMING ERROR CORRECTION
Timing errors
One source of error is a misplaced head which affects vertical edges on the picture.
Correction
Video is compared with a stable reference such as local line sync. Any discrepancy produces a correcting voltage which reduces or increases a delay in the video path. 1, Uncorrected video. 2, Line sync extraction circuit. 3, Comparator. 4, Variable delay. 5, Correcting voltage. 6, Corrected video output. 7, Stable reference (line sync).

Colour is more critical of precise timing.

Accessories: Colour Only Corrector

The time base error corrector previously described is satisfactory only for monochrome because it does not reduce errors to sufficiently narrow limits for colour. A method, similar in principle but using a different stable reference, may be used for colour correction. The stable reference used in this case is the colour burst (see page 40) rather than line sync. The burst is stripped off the signal as it is replayed off the tape and compared with a feed of burst from the station generator. Any discrepancy between them produces a voltage which sets the delay line to give the required timing stability. This colour corrector works only within fine limits and is needed in addition to the monochrome corrector, the latter being used first to reduce coarse errors after which video is passed through the colour only corrector.

Pilot tone
This method is used only in CCTV recorders. One technique is to record an extra signal on top of the video called a pilot tone. On replay this signal is subject to the same timing errors as the chroma and is called a sympathetic reference. In demodulating chroma it is customary to use the colour burst as a reference which stabilises the process over long periods. In this system, since the pilot tone is continuous and subject to the same timing errors as the chroma it can be used to initiate continuous adjustments to the process of demodulation. The process does leave us with a demodulated signal and if a composite colour signal is required it is necessary to encode the signal again (see page 40).

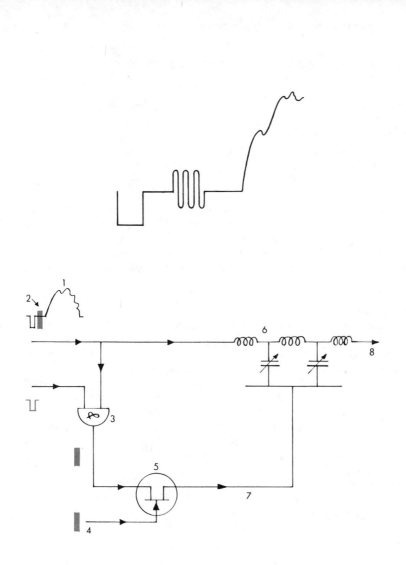

COLOUR ONLY CORRECTOR

This works in the same way as the time base corrector but uses the colour burst instead of line sync as reference. 1, Video from tape. 2, Colour burst. 3, Burst extractor. 4, Station reference burst. 5, Comparator. 6, Variable delay line. 7, Correction signal. 8, Corrected video.

Accessories: Sync Processor

Considering the stages a video signal passes through in a recorder i.e. modulation, recording, replaying, switching, demodulation, it is not surprising that the output signal is not a precise replica of the input. Recorders are designed so that the distortions which do occur, introduce insignificant picture impairment and work satisfactorily in the environment they are intended for. The processor eliminates the misshaping of sync pulses. For CCTV purposes the reproduced syncs need only be good enough to operate the monitors they are connected to and processors are provided only in the most expensive installations. For broadcast purposes the duration, shape and amplitude of sync pulses and blanking are set to a precise specification, which waveforms out of recorder demodulators do not meet.

The processor strips sync pulses off the demodulated video output, reshapes and times them. Syncs and blanking are then added to the video as shown opposite. A line sync before and after processing might appear as at 6 and 8.

The general technique is for the processor to, in effect, be a pulse generator controlled by syncs off the tape. The pulse repetition frequencies of pulse generators are controlled by an external feed of twice line frequency, this being the highest frequency required. Other frequencies such as line and field rates are obtained by dividing down from the twice line frequency input. We can see in the diagram that sync pulses are separated from the picture signal and fed into a phase comparator. They are compared with another line frequency signal obtained by dividing by 2 the output from a twice-line-frequency oscillator. The comparator output controls this oscillator which in turn produces the required pulses. These pulses are independent of distortions occurring in the recorder.

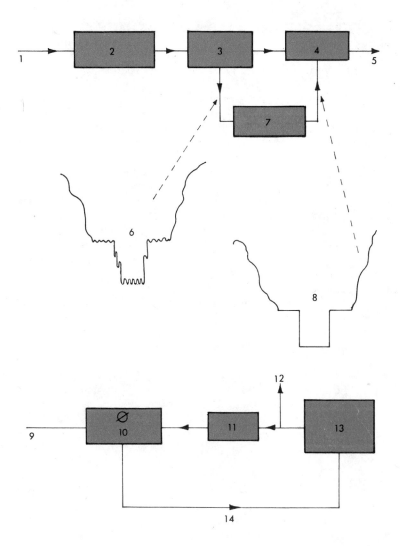

SYNC PROCESSOR

Processor
The somewhat ragged syncs of the demodulated tape signal are stripped off and
clean ones inserted. 1, Video off tape. 2, Demodulator. 3, Sync separator.
4, Sync adder. 5, 8, Processed video. 6, Video before processor. 7, Processor.

Processor pulse generation
The processor pulse generator requires its own source of twice line frequency to
be derived from line syncs off tape. 9, Line syncs from tape. 10, Comparator. 11,
Divide by 2 circuit. 12, Twice line frequency signal to processor. 13, Twice line
frequency oscillator. 14, Oscillator control signal from comparator.

Editing: Physical on Quadruplex

Editing is the process of cutting out unwanted sections of tape or re-assembling sequences in a different order to compile a finished tape. Physical editing is the process of actually cutting the tape and sticking the wanted sections together, just as one would edit a film. Cutting must be precise in order to preserve synchronism, i.e. the continuity of the control track waveform must be preserved so that the servos are not disturbed when an edit is played back.

Considering quadruplex first, the tape should be cut between video tracks and special splicing machines are available to make the cut at the correct angle. Subjectively, it is best if the cut is made during field blanking and the join should be made so that a field ending on a half line (an odd field) is joined to one ending with a whole line (even) or vice versa. Although we have used the term 'picture' for two fields, VTR terminology has followed the film industry and a complete picture on tape is called a frame. As a reference point for accurate tracking one pulse is recorded on the control track. The tape is saturated by this pulse and its position can be located by brushing on a special liquid containing iron carbonyl powder. The particles cluster around the edit pulse which becomes visible. Its actual position with respect to field blanking varies between machines depending on the position of the control track head.

A remaining difficulty is that of sound which is downstream from video by 0.6 second because of the $9\frac{1}{4}$ in gap between sound and video heads. Suppose we have recorded someone pressing a switch. Then on tape there will be a space between the video signal of the switch being pressed and the point on the sound track where the associated click is recorded. Suppose now we wish to cut immediately after the switch has been pressed and splice on a piece of tape of a lamp lighting. If we cut at 4 (see opposite), the switch click is lost and if we cut at 5 we have 0.6 seconds of picture too long. An L-shaped splice is not practicable and where such accurate editing is necessary the solution is to record the sound on a separate tape, cut at 4 splice and record the click on afterwards.

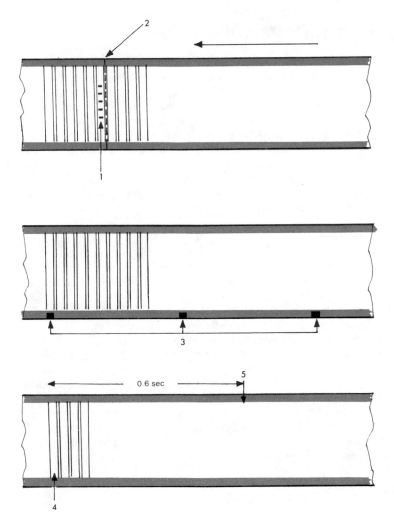

PHYSICAL EDITING ON QUADRUPLEX

Cut position
The cut (2) should be made in the guard band following the video track
containing a field sync pulse (1).

Edit pulse
The reference point for cutting is an edit pulse (3) which can be 'exposed' by
brushing a liquid containing iron carbonyl powder on to the control track. The
splice point relative to the edit pulse is not standardised for all machines.

Sound
Sound (5) is downstream from the corresponding video (4) by 0.6 second.

Editing: Physical on Helical

The requirements of editing tapes recorded on helical machines are the same as for quadruplex but the formats give rise to a further difficulty. The slant of the tracks makes it impossible to *cut in the band* between them and make satisfactory splices. However a cut may be made at right angles to the tape edge. Again the control track can be magnetically 'developed' to make the splice synchronous and for a particular format a splice might appear as shown. From this it can be deduced that, as the tape is played back, a vertical wipe is produced moving, in this case, upward. For other formats or tape directions the wipe should be downward.

General hints

1. Handle the tape with care and avoid touching its surface.
2. Keep all equipment clean and demagnetized. Airborne dust particles deposited on the surface of the tape inevitably cause drop-outs.
3. Align the tape accurately to form a butt join without a gap or overlap and ensure that longitudinal edges are aligned.
4. Apply adequate pressure to the adhesive tape.

Physical editing requires care and expertise on behalf of the editor and mistakes are normally disastrous. It is expensive because of the time taken in man and machine hours and the fact that it is inadvisable to use the tape again for recording.

Its only advantage is that the final product consists solely of the original recording and as such is said to be first 'generation'. In editing methods which use dubbing, some deterioration of quality is inevitable (see page 144).

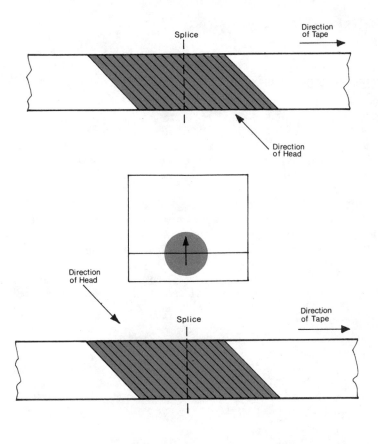

Splice

Direction of Tape

Direction of Head

Direction of Head

Splice

Direction of Tape

SPLICING HELICAL TAPES

A physical splice gives the effect of a vertical wipe.
If the tape and head motion oppose each other (most formats) the wipe is upward.
With the tape and head in the same direction (Philips VCR) the wipe is downward.

Editing: Electronic

In this process we have a recorded tape and from a certain point on it we shall erase the recorded material (outgoing) and on to the clean tape we shall record material from some other source (incoming). The other source will be a video signal either from another tape machine or indeed from any other video source such as a studio picture. There are two basic methods, insert, and add-on or assemble, they differ in the way in which the capstan motor is controlled and as a consequence have different operational requirements.

Insert

Before editing there must be a continuous control track recorded along the whole length of tape ultimately required, and this control track must not be altered during an edit. To begin with the tape is replayed and when the splice point is reached the machine is switched into the record mode to record the incoming signal, but the original control track still controls the capstan. If it is necessary to retain material on tape after the insert the incoming and outgoing signals must be synchronous.

Add-on or assemble

In this case the recorder assumes its normal recording mode at the splice point. The disadvantage is that in switching the capstan from replay to record mode there will be some disturbance unless the incoming and outgoing signals are synchronous.

Synchronisation of record and erase switch-on

If, at the instant of switching into the record mode the erase current is also switched on, the record head has to record over tape with video tracks on it for the time it takes the tape to pass between the two heads. For quadruplex, when the record button is pressed the erase comes on for the first gap after the track containing field blanking, and the record drive is electronically delayed to come on when the first erased track reaches the record head.

This cannot be done with helical recorders because the erase head cannot be aligned with the tracks. On some machines a 'flying' erase head is mounted on the head drum timed to erase the unwanted tracks in advance of the record head. The simple solution is to record on top of the unwanted tracks and suffer the small increase in noise.

The reverse problem occurs coming out of a splice; if record and erase drives are cut simultaneously there will be a blank section of tape. This can be avoided by cutting erase just before the end of the edit and then cutting record after the time it takes the tape to pass around the drum. Again the delay may be provided electronically.

100

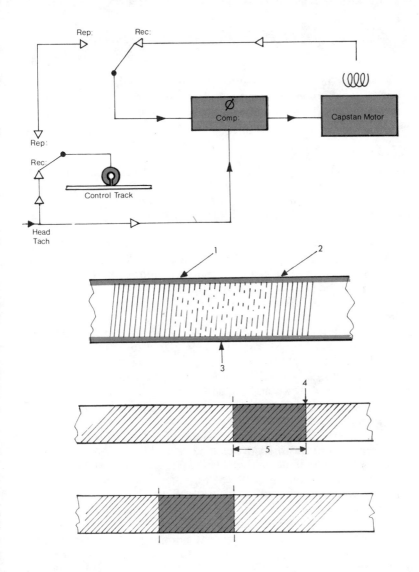

ELECTRONIC EDITING

Capstan control during add-on edit
In going from replay to record the capstan control changes from head tach to control track.

Timing record and erase switch-on
Quadruplex: Section 3 is not erased if erase (2) and video (1) heads are switched on simultaneously.
Helical: If the machine is switched to record with the erase head at 4, section 5 is not erased. As the tape moves on new video is recorded on this unerased section.

101

Reading Specifications: Sound

For some applications the best performance is required. The best, however, is normally expensive and it is economic to settle for a specification good enough for a particular application. To do this some knowledge of the technical jargon is required.

Bandwidth
This might be quoted as ±3dB 50 Hz to 12 kHz. 50Hz is the lowest frequency reproduced while 12 kHz is the highest.

The ±3dB is simply a way of describing the limits over which the amplitude changes, ±3dB or 6dB being a ratio of 2:1.

Distortion
Distortion shows itself as extra frequencies, multiples or harmonics of the input signal, on the playback signal. It is normally expressed as a percentage of the peak output signal. A typical figure is 3%.

Noise
Noise is the background sound which every tape recorder adds to the playback signal. It is also expressed as signal level relative to the maximum output signal in dB. The figure given is normally between 45dB and 55dB. Where 48dB means the noise power is 1/256th of the peak signal (54dB would be 1/512th).

Wow and flutter
This is a measure of the cyclic changes of the pitch of a replayed signal. Wow expresses the slow change and flutter the rapid changes in pitch. Normally it is caused by changes in tape speed and is expressed as a % change in pitch or frequency. Typical figure 0.15%.

Comparison of specifications

	Professional	CCTV Master Recording or Music	CCTV domestic or speech
Bandwidth	30Hz–20kHz	50Hz–12kHz	100Hz–8kHz
Distortion	1%	3%	5%
Noise *rms signal* rms noise	55dB	50dB	45dB
Wow and Flutter	0.1%	0.15%	0.2%

Sometimes a *weighted* noise figure is given. This takes into account the ear's sensitivity to the frequency of the noise. A weighted noise figure is normally 2–6dB better than shown above.

Another ambiguous practice is to quote peak signal output, giving a noise figure 9dB better than if rms were used.

 = +

Distorted Signal Fundamental 3rd Harmonic

 + =

Signal Noise 1 Watt Signal
 $\frac{1}{256}$ Watt Noise
 (Signal/Noise ratio: 48 dB)

Signal Wow added in Changes of Pitch
 machine

TYPES OF DISTORTION

Non-linearity
Amplitude distortion can be expressed as a percentage of a harmonic.

Noise
The added noise can be expressed as a fraction of the signal.

Wow and flutter
Wow and flutter can be expressed as a percentage change in pitch.

103

Reading Specifications: Vision

The vision signal, being an electronic signal like the sound, has similar specification characteristics. The impairment of the signal, however, shows itself in a different way.

Bandwidth

Video frequencies extend to 5.5MHz for broadcasting standard 625 line colour signals. The colour information or chrominance needs a bandwidth of only 1MHz, because human perception of colour detail is limited. For CCTV purposes the black and white signal bandwidth may extend only to 2.5MHz with the colour information reduced to 0.5MHz. The effect of reducing bandwidth is to reduce detail in the picture.

Distortion

A special waveform called a pulse and bar is used for measurements. Distortion on this signal can be expressed as a K rating representing a subjective impairment. A K rating of 2% is excellent while 10% is typical for CCTV recorders.

Noise

Noise gives a subjective effect of snow on the picture and is also expressed as a ratio of signal level to noise level. A ratio of peak-peak signal to rms noise of 40dB would give just perceptible noise. Some manufacturers also add the sync pulse to the video level making their quoted signal-to-noise ratio seem about 3dB better than it really is. The higher the dB figure the less the noise.

Time base stability

This is normally only of concern when mixing the playback of a VTR to a stable signal; a specification has been laid down called RS-170. For monochrome the time base stability should be within 50 n sec. (50 × 10^{-9} sec.) where for colour it should be ±3 n sec.

Comparison of specifications

	Professional	CCTV Master Recording	CCTV Domestic
Bandwidth			
Luminance	0-5MHz	0-3MHz	2MHz
Chrominance	1MHz	1MHz	0.5MHz
Distortion	1% K	4% K	10% K
Noise			
Pk-Pk video/rms noise	44dB	42dB	38dB

104

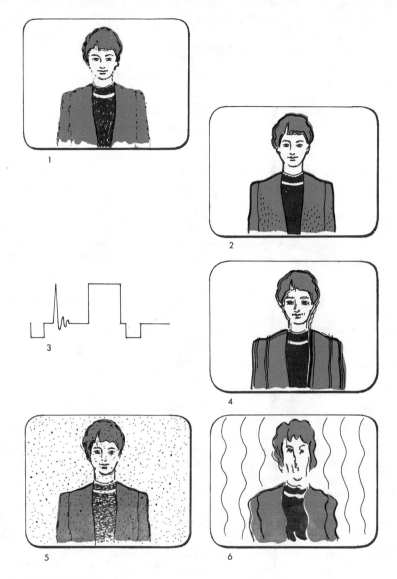

VIDEO PERFORMANCE

Bandwidth
Loss of high frequencies gives a blurred picture (1) while a full bandwidth gives sharp crisp outlines (2).

Distortion
A pulse and bar waveform (3) can be used to measure distortions such as ringing (4).

Noise
A snowy picture (5) is caused by the addition of random noise.

Instability
Time base instability gives the effect of a wavy picture (6), especially if it is mixed with a stable source.

Questions on VTR Sound

Do I need two audio tracks?

This is sometimes useful for two languages or to give a simple description on track 1 and a more detailed description, for advanced students on track 2.

For international exchange of tapes it is convenient to have music and effects on one track and commentary on the other. This makes the re-dubbing of the commentary easier.

When would I use the 'audio only' record facility?

Audio and video mixing requires a lot of co-ordination between several people. It can sometimes be easier, particularly if one is short staffed, to record the vision first and add the commentary and music afterward, or vice versa.

When would I use 'line-in' as opposed to a 'microphone' input?

The outputs from sound mixers, tape recorders, amplifiers and record players are all at line level (0dBM or 0VU.) and should be used in preference to the microphone input. However if a simple commentary is required, the microphone input can be used.

What is 'line-out' for?

Most video-tape recorders are fitted with an internal loudspeaker and a socket for an extension speaker. This is satisfactory for a group of up to 30 people. If the sound signal needs distribution to a larger number of people or to other parts of a building then the 'line-out' should be used. (See VTR Connections – page 110).

If the sound output of the VTR needs to be mixed with another source then again the 'line-out' must be used.

When would a 'balanced line output' be used?

A balance line gives better rejection to stray unwanted signals, like hum, which are sometimes picked up along the cables. If large lengths of cable are used for distribution, say 100 ft or more, then balanced input and outputs should be used.

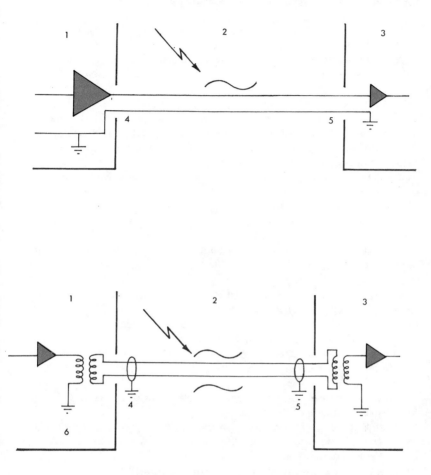

BALANCED VERSUS UNBALANCED

The output (4) of the playback VTR (1) is connected to the input (5) of a record machine (3) or sound mixer by two wires.

Unbalanced
In an unbalanced system one wire is earthed. Any hum (2) picked up on the signal wire is added to the signal.

Balanced
With a balanced twin wire system the hum is induced in both wires but is cancelled in the transformer. For extra hum immunity a screen connection may be made to earth.
The extra expense of balanced input and output transformers (6) is important for long cable lengths or low level signals such as microphone outputs.

Questions on VTR Video

Can a colour VTR also record black and white?

Yes, but the reverse is not possible. A special VTR is required for colour signals.

When would I use RF out?

This is useful when playing back into an ordinary unmodified domestic receiver. The video is modulated on to a spare VHF or UHF frequency band and connected to the aerial socket of a receiver which is then tuned in the usual way. Remember that the signal may be radiated over a small area and care must be taken with tapes of a secret or personal nature.

Why is 'video-out' required?

This can be displayed on a video monitor which is similar to TV receiver. It should also be used for distribution or for mixing with other signal sources.

Can the output of a video tape recorder be mixed with the output of another camera?

Only if it can be locked to external sync and for black and white if its playback stability meets RS-170 standards.

For colour the stability requirements are even tighter and the manufacturers advice should be sought.

I have only one camera; is it worthwhile investing in an electronic editor?

Ironically it is most probably more important because you can assemble a programme with various shots and captions simply by editing single camera shots.

What tape should I use?

Be guided by the recommendations of the machine manufacturer. Different machines use differing widths of tape and accept different size spools. Some machines require 'high energy' tape while others can use it for improved quality. Standardize on one type and brand of tape. *Do not mix types of tape* as your machine should be set-up and optimized for one particular type.

Tape is expensive, do not be afraid to reject tape and return it if its performance is poor in terms of drop-outs, head wear or physical condition.

RF Out

Video Out

A

B

C

or

D †

or

E

VIDEO OUT OR RF OUT

The RF output of a VTR (B) can only be used to connect into the aerial input of a
domestic receiver (A).
The video output should be used for a monitor (C), a vision mixer (D) or another
video recorder (E).

Connections to a VTR

Simple domestic set-up

A conventional television receiver is normally used and the vision and sound signals are connected to the receiver through the aerial socket.

The VTR sometimes has its own tuner and therefore can record directly from the household aerial. This means that the user can watch one local transmitted programme while the recorder is recording another.

During playback the VTR vision and sound are placed on a spare channel and the receiver tuned accordingly.

Simple CCTV set-up

In a CCTV installation the user normally wishes to record his own vision and sound signals and these can be connected directly from the camera and microphone. The vision, which can be monitored during recording as well as playback, is displayed on a television monitor or on a receiver modified to accept video signals. The sound is normally replayed on the VTR internal speaker.

Complex CCTV set-up

In order to make up a programme, several sources may have to be mixed or selected prior to recording.

Also it may be desirable to play back to several separate areas. This entails the addition of several extra pieces of equipment to the VTR. A remote control unit is also useful to isolate the VTR noise from the production areas.

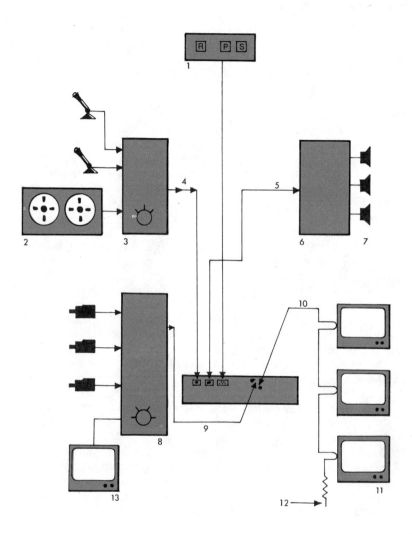

A TYPICAL CCTV ARRANGEMENT

The output of an audio mixer (3) is connected to audio in with microphones, an audio tape recorder (2) or turntable on the input to the mixer. Audio out (5) is connected to a distribution system (6) to feed loudspeakers in various locations. Video in (9) is from a vision mixer (8) with cameras on the input to the mixer. A vision monitor (13) monitors programme output. Video out (10) could feed several monitors (11) if the usual precaution of terminating the last monitor is taken (12). A remote control panel (1) for the VTR is connected to a multi-way socket.

111

The VTR Area

The audible noise from the VTR is certainly loud enough to be picked up by a microphone. For a simple record set-up the VTR should be placed far away from the microphone and if possible in another room.

Small installations
For studio operation the VTR should certainly be removed from the studio area into a separate room and if possible away from the main control area. An ideal situation for small installations is one where there is visual contact between operational areas and complete audio isolation apart from an intercom, between sound control, vision control and VTR.

Large installations
With larger installations where several VTR's are used it is better to keep all the recorders in a central area. This normally means losing the visual link with the studio.

In a central VTR area sound isolation is desirable between machines except when editing from one machine to another. A good compromise is editing pairs of machines with a sliding door between them which can be closed if required. The two machines making up a pair should complement each other.

The record machine should be fitted with an editor and any edit cueing device required, while the playback machine should be fitted with the timing correctors and accessories to improve playback quality such as burst equalizers, drop-out compensators and processors.

Environment
Wherever the VTR is used care should be taken to minimize dust, particularly chalk in school situations. Smoking should not be allowed.

If possible the temperature and humidity should be controlled. If the area is uncomfortable for people it is certainly unsatisfactory for the tape and the recorder.

Facilities
Near the VTR should be a small desk to write reports, a shelf to place cleaning fluid, tissues and degausser, a clip board for notes and instructions and enough bench space to undertake local repairs.

It should be possible to disconnect the machine easily without desoldering leads and *at least* 2 extra mains sockets should be provided for test equipment and soldering iron.

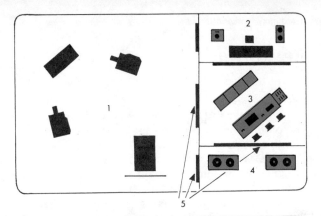

STUDIO LAYOUT

Control Rooms
The studio (1) should be acoustically insulated from technical areas such as vision control (3) sound control (2) and VTR (4) by double glazed windows (5).

Larger VTR areas
VTRs (6) should be isolated from each other with the opportunity of forming editing pairs by sliding doors. Assignment for the machines (7) should be in a central position.

Maintenance
A maintenance area should have video and audio test signals (8) plenty of mains sockets (9) and shelves for cleaning material (10).

VT recorders are easy to use, but need properly trained maintenance.

VTR Personnel

Operational

The controls on a helical VTR are only a little more complicated than an audio recorder. The lace-up on reel-reel recorders can be quite tricky, although cassettes have now removed this problem.

Anybody therefore can soon learn to use a VTR. For studio work however a quick agile mind and a certain amount of dexterity is required when production gets complicated.

The mistake normally made is to assume that technicians are required to operate the recorder just because it is a complex technical device. In fact, young people with no technical background adapt very quickly to the operational side of video recording.

Editing requires more skill, aesthetic appreciation and experience than normal operations. In larger installations therefore it is wise to allow some individuals to specialize in this field.

Maintenance

To repair video recorders and keep them at peak performance requires some skill and technical background.

One technician can look after three or four machines, adjusting, optimizing, repairing and setting up recorders for the day's recordings. Such people, normally of ONC level, with experience, can be difficult to find and the next best solution is to take out a maintenance contract with the manufacturing company or their local agent.

If you have only one machine this is certainly needed as you have no spare and it is un-economic to employ a specialist.

Some manufacturers will lend a good machine while the customer's machine is being repaired.

If you do employ your own maintenance man do send him on a recognized training course. The results with improved performance and reliability will soon pay dividends.

Never allow anyone to make adjustments unless they are certain they know what they are doing. The fewer the people in a VTR area with a screwdriver the better.

PERSONNEL

Editing
Technical knowledge is not required, but a well organised agile mind. It is very easy to get confused especially when editing.

Maintenance
Only trained technicians should be allowed to adjust machines. Nobody else should have a screwdriver. A VTR is a delicate and sopisticated instrument requiring expert attention when faulty.

115

Care for the Tape

Everybody who handles videotape should know how to care for it. Not only does this ensure longer life but also gives improved performance with fewer drop-outs, head clogs, mistracks and better stability.

The following instructions should be displayed near the VTR until all personnel are completely familiar with it.

1. Lift videotape by the hub or by the lower flange. Never squeeze the flanges as this can damage the edges of the tape.

2. Do not smoke near a VTR or use chalk; avoid any dusty environment.

3. Once the tape is laced-up avoid touching the surface oxide with the fingers.

4. Allow reels to coast to a stop after playing or rewind. If the reels are touched stretching can occur.

5. Examine the tape pack before replacing the tape into its box. Rewind if wind is loose or if windows and cinching have occurred.

6. Store videotape in its correct box with a hub support. Stand boxes upright during storage.

Tape should be in one of two places only – either on the transport or in the proper box.

7. Store videotape away from magnetic fields like those created by electric motors, transformers, loudspeakers, demagnetizers, etc.

8. Store videotape under conditions that are comfortable for people: not too hot or cold and not too dry or humid.

9. If tape has suffered adverse temperature conditions during transit allow the tape time to normalize to its operating conditions. This can be done by placing it near the recorder for at least 24 hours.

10. Do not write on the end tab while it is on the reel of tape. The writing pressure dents many layers, causing drop-outs.

11. Cut off the wrinkled and damaged end of a reel of videotape. Never thread it through a machine.

12. Avoid splicing tape when possible but if a splice is necessary keep tape clean and free from creases.

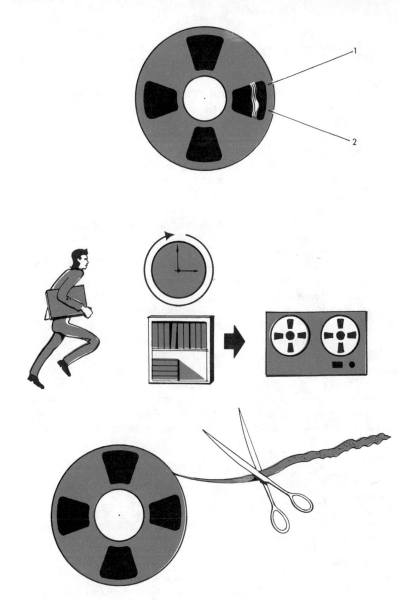

CARE OF TAPE

The tape pack
This should be inspected for smooth pack (1) or cinching (2). Tape transports
should be checked if this occurs.
Tape in transit should be allowed to normalize in temperature before playback.
Twenty four hours at least being needed in the VTR area prior to placing on
machine.

Damaged leader
This should be cut off in order to avoid damage to heads. The beginning of
programmes should be started well into the tape to allow for this.

117

Looking for trouble

Any device can break down and sometimes it seems that it always fails during the most important occasions. Videotape recorders are no exception and because the programme prepared has taken a lot of effort it is normally difficult to make up for its loss.

For very important playbacks a standby machine should be available but as this is expensive and not always possible the next best solution is to be able to detect faults before complete breakdown.

In this respect a good operator should be on the look-out for changes in performance and a qualified maintenance engineer should periodically check machine performance. Continuous adjustment of internal pre-set controls is not recommended as this will certainly lead to future unreliability when components wear.

Operators should be alert to the following:

1. Strange noises. All VTRs have a characteristic sound, normally a steady hum accompanied by a high-pitched whistle. Most operators soon get used to this normal sound. Investigate any strange noise.

A change in pitch or on oscillating pitch from the head-wheel may mean that the head servo has lost lock or that it has gone unstable.

A bent spool is normally indicated by a brushing noise as it runs on the edge of the tape. If the tape tension is excessive it sometimes leads to a squealing sound as the tape binds itself around the drum.

A worn motor bearing will normally start to rumble well before it shows itself on the playback performance of a machine.

2. Creasing of the tape. A poor or uneven wind normally indicates that the tape tensions need adjusting. Sometimes this shows itself as cinching with windows in the reel pack.

If this occurs the following should be checked:

(a) Play or record take-up tensions and holdback torque.
(b) Rewind hold-back torque.
(c) Parking brake tension.

General performance

Anything unusual in general performance should be noted by the operator. For instance if the VTR is taking a longer time than usual to lock up and give stable pictures or if there are any problems in playing back tapes from other machines. Compatibility problems can be detected well before the complete inability to interchange tapes. First the tracking range over which an acceptable picture can be obtained becomes small. Secondly, it is sometimes noticed that interchange between two particular machines is worse than between other machines. Do not live with this situation but get all machines checked. Playback quality should be checked to observe any trend in deterioration of performance.

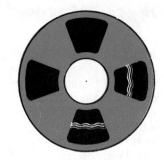

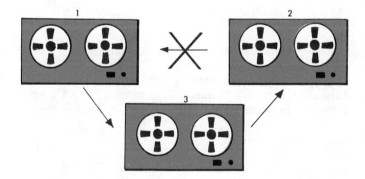

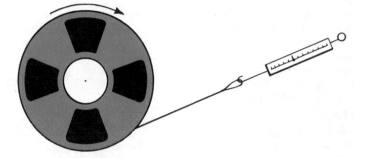

MOST PROBLEMS CAN BE FORESEEN

Poor tape-pack
If this occurs the tape tensions should be checked and adjusted, with the aid of a spring scale, to the values given in the hand-book

Interchangeability
Do not live with a situation where some tapes can only be played on certain machines. Get the geometry checked.

For rapid fault location, learn to recognise symptoms.

Play Back Faults

The following tables list the most frequent failings with probable causes.

Complaint	Possible causes
Video	
Generally noisy	Low head penetration. Clogged head. Low level record current. Video level too low in record.
One or two bars of noise on picture	Mistracking due to wrongly set tracking control or mechanical guides. Capstan servo off lock. Edge damage on tape.
Intermittent black flashes on picture. Sometimes with picture break-up.	Drop-out caused by bad tape or insufficient head penetration.
Occasional complete loss of picture.	Head clog caused by poor tape or low head penetration. Bad video connector.
High frequency RF pattern	Limiter or demodulator balance control.
Low frequency beat pattern	Poor erasure caused by clogged erase head or low drive. Mistracking as above.
Sound	
Playback level low	Record level low. Clogged head. No bias. Faulty connector.
Distortion on playback	Incorrect level of bias. Damaged tape edge. Record level too high. Poor head-to-tape pressure.
Buzz on sound	Poor erasure of video tracks. Incorrect carrier frequency on RF output.
Poor HF response	Bias level too high, azimuth of head incorrect. Poor head-to-tape pressure. Clogged head.
Wow or flutter	Capstan dirty or worn. Servo off-lock. Bent spool.

120

PLAYBACK FAULTS

Mistracking
On helical machines horizontal bars of noise are formed which move up the picture if the capstan is off-lock.

Drop-out
This can be caused by worn, badly handled tape or low head penetration.

Oxide Build Up
Clogged heads (1) or dirty capstans (2) are a common source of problems which can be eliminated by regular cleaning.

Cleaning and Degaussing

Dirt in the form of particles of oxide and binder (see page 86) is the main cause of drop-out. Such dirt gets on to the tape from the transport unless the transport is kept clean and causes excessive head wear as well as drop-out. There are two types of solvent for removing dirt:

1. Tape oxide binder solvents such as xylene which are very efficient for removing oxide particles. However they also remove oxide from the tape coating so they should be used sparingly and allowed to evaporate before putting the tape on to the transport. Further they must not be brought into contact with paint, plastic or rubber.

2. Non-binder solvents such as freon or carbon tetrachloride are more commonly used because they are safer although less efficient at removing dirt from awkward corners.

All cleaning solvents are somewhat toxic and should not be used in confined spaces.

Solvents are best applied with a lint free cloth and all areas including the heads should be rubbed vigorously. Cotton buds and ordinary paper tissues should not be used because they release fluff which can block the vacuum guides. An eye lash brush is useful for cleaning out awkward corners. *Cleaning should be done straight after a recording or playback before the oxide and binder can harden.*

Degaussing

If a recorded tape passes over a magnetised part of the deck some degree of erasure may occur and cause the signal to become noisy. For this reason it is good practice to demagnetise the transport, at least daily. The usual technique to demagnetise anything is to put it into a strong alternating magnetic field and then slowly reduce the amplitude of the alternations to zero. For a tape deck the field is provided by a hand-held degausser which is brought near to the metal part and *slowly* drawn away from it.

CLEANING AND DEGAUSSING

Build up of oxide should be removed using a recommended solvent (7). A lint free cloth (5) should be used for large areas such as audio heads (4) and head drums (3). Oxide (2) in unaccessible places such as tape guides (1) can be removed with solvent on an eye lash brush (6).

All metallic parts such as video heads (8) tape guides (9) audio heads (10) should be de-magnetized by bringing the degausser close to the object and slowly moving away.

For high-quality sound, follow correct alignment procedures.

Aligning the Sound Section

The manufacturer's handbook should be consulted before making any adjustment, but the following procedures are common to most machines.

The playback section of a tape recorder should have the same sensitivity, over its frequency range, as all other recorders.

Similarly the record sections should be matched so that all machines produce a recording to the standard.

Playback section
The playback section is aligned first with the aid of a Standard Alignment Tape which can be purchased from the recorder manufacturer.

This tape is a precision recording, with a long section of 1KHz or 400Hz tone at a fixed level followed by shorter sections of lower and higher frequencies from 50Hz to 15kHz.

Before using this tape the machine should be cleaned and degaussed well to avoid partial erasure of the recorded signals.

A typical procedure would be:
1. Clean and degauss the machine.
2. Lace up tape, initiate play and set Playback Level for correct reading on a level meter. (This level is stated on the tape and may be 0 VU, 0dBM, +8dBM or +14dBM.)
3. Play back the range of frequencies and adjust Playback Equalizer for a flat response.
4. Re-check 2.

The playback chain has now been set up.

Record section
The record section should now be aligned so that from input to output the VTR gives unity gain, minimum distortion and the flattest frequency response.
1. Lace up a new tape.
2. Insert a tone (400Hz or 11kHZ) or a known level into the audio input.
3. Initiate Record and set Bias Level by first turning fully down and then increasing in steps until the playback signal reaches a maximum and then falls slightly. The value of bias which gives a playback tone 1dB below the maximum is optimum for minimum distortion.
4. With optimum bias, record tone and adjust Record Level until the playback signal is the same level as the input signal, i.e.: unity gain.
5. Record frequencies over the same range as the alignment tape and adjust Record Response until a flat response is achieved, in playback, of the recorded signals.
6. Re-check 4.

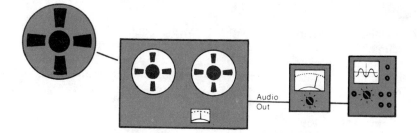

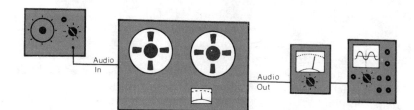

AUDIO ALIGNMENT PLAYBACK

The playback channel is aligned with the aid of a standard alignment tape. The
playback level being measured on a meter or oscilloscope.

Record
Signals are recorded from an audio oscillator and the record electronics set up
for unity gain from input to output over the audible frequency range.

125

Don't fiddle with controls! Only skilled adjustments produce optimum results.

Vision Record Adjustment

This section and the one on the following page are meant for the technician and adjustments should be made only after reference to the manufacturers hand-book. *If in doubt leave alone!* The method of adjustment indicates how to check if adjustment is required in the first place.

Carrier frequency
If the carrier frequency is too low, an unwanted RF pattern appears at black-level on the output vision. If it is too high, the playback picture starts to break up.

The most accurate method is to check the modulator frequencies against a crystal oscillator.

If the black-level frequency is added to the modulated signal at the input to the demodulator, a beat occurs between the two signals. The carrier frequency is adjusted for a low frequency beat at black-level.

Deviation or input gain
The deviation control sets the white level frequency and is set in a similar manner to the carrier frequency. With a video input of 1 V peak to peak and the crystal oscillator, set to peak-white frequency, the deviation is set to produce a low frequency beat at peak-white.

Record current
The drive to the head should be set to just saturate the tape. To determine this point the record current should be increased from zero in small steps. This can be monitored with an oscilloscope on a test point somewhere in the record amplifier. During the recording the operator can make a spoken commentary on the audio track of the monitored level. Monitoring the resultant RF, on replay shows that as the record current is increased the playback e m f also increases until finally it reaches the point of saturation. The record current setting that brings the playback e m f just up to a maximum is optimum and the record current should be reset to this value.

Drop-out position
This is really a servo adjustment which positions the record head to leave one track and start the next at a chosen part of the TV picture. If the DO is not in the correct position (bottom of picture or vertical blanking) it must be adjusted during recording and the position checked in playback. This can be set by trial and error.

126

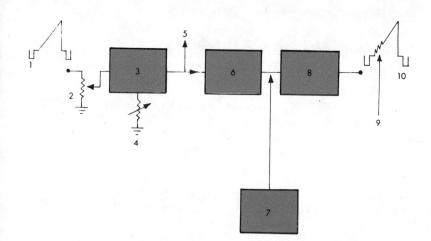

VIDEO ALIGNMENT

The modulator (3)
With crystal oscillator (7) signal injected between the limiter (6) and the demodulator (8) the black level carrier frequency can be adjusted on a sawtooth signal (1) for a minimum beat (9) on the output signal (10). Deviation (2) can be adjusted by injecting a frequency corresponding to peak white and tuning for a minimum beat as in (11).

Drop out on one headed helicals
This should be adjusted in record for a loss in picture information during playback, either at the bottom of the picture or in the vertical blanking period.

127

Vision Playback Adjustment

Playback gain
This should be adjusted when playing back a tape with known correct carrier and deviation. The output video level should be adjusted for one volt peak-to-peak when terminated in 75Ω. This control has the same effect as "contrast" on the monitor or receiver.

Tracking
This adjustment, normally an operational one, should be set on every playback and checked throughout the programme. If a meter is provided it should be set to give a maximum deflection. At this position the video head is aligned exactly to its video track.

Playback equalization
This is best set using a test signal with a high frequency component (multiburst or colour-bars). It can be adjusted to give the flattest possible frequency response with minimum distortion and noise. If such a signal is not available, a similar signal can be obtained from a camera viewing a grating or chequered pattern. The control can then be adjusted subjectively to give the sharpest picture without distortion or objectionable noise.

Tape tension
This is adjusted for minimum hooking at the top of the picture and may have to be adjusted throughout the programme playback.

Limiter and demodulator balance
This should not be adjusted unless the playback picture is covered with an objectionable RF pattern and then only if all other checks have been made. Both balance controls are normally set to give a minimum RF pattern but as the controls are interdependent it is advisable to go back and forth between the two until the minimum is found.

128

COMMON ADJUSTMENTS

1. Tracking
This can be adjusted on playback (1) either for maximum signal off tape as indicated on a meter (3) or minimum noise on the picture (2).

2. Moiré
This is normally a screwdriver adjustment (4) called demod or limiter balance and should be set for minimum RF patterning (5).

3. Tape Tension
This should be adjusted on playback (1) for minimum hooking at the top of the picture (7).

Ensuring Good Results

A simple operational check procedure before each recording and playback should be carried out. In this way technical hitches halfway through a programme can be avoided and any adjustments can be made *before* recording or transmission.

Before recording
After cleaning the machine the videotape operator should check sound and vision levels from the source (either the microphone and camera or the mixer). This can be done by either sending a line-up signal like sawtooth and tone or a typical camera picture and sound signal.

Gains should then be adjusted to give the correct input levels to the recorder. If it is not possible adjust the gain at source, the input level controls on the recorder may be used.

Vision overmodulation (too high a level) causes picture break-up and undermodulation excessive noise.

Sound overmodulation causes distortion and undermodulation a weak and noisy signal. Once the levels have been set, a short test recording should be made on the tape being used for the programme, and the playback performance checked.

Finally a leader should be recorded on the start of the tape. This should consist of:
1. 30 seconds of sawtooth and tone (if possible).
2. 30 seconds of black-level.
3. 30 seconds of 75% colour bars (if colour used).
4. VTR clock (page 138).

This is left on the tape prior to the programme and used to line up the machine for playback.

In the studio
Before recording it should be checked that all scenes are correctly lit and producing the correct video levels. This can be done by panning the cameras over the proposed areas and checking the video levels on an oscilloscope or the VTR level meter.

The same should be done with the sound by checking that the sound does not fluctuate when the artists move around to their various positions.

If it is not possible to light the scene or position the microphones to maintain adequate vision and sound levels, the camera lens aperture and sound level should be adjusted accordingly throughout the recording.

RECORD LINE-UP

1 Clean and Degauss Transport
2 Check incoming Vision Level
3 Check incoming Sound Level
4 Adjust Video and Sound Gains for ¨O¨ on Meters
 (or on Oscilloscope)
5 Lace-up Tape and Test Recording
6 Record first part of Leader and set-up
 Playback Controls
7 Inform Studio that you are ready to
 Record VTR Clock

PLAYBACK LINE-UP

1. Clean and Degauss Transport
2. Lace-up Tape
3. Replay and adjust Tracking and Tension
 Controls
4. Adjust output gains on Sawtooth and Tone Signals
 for correct Video and Sound Levels
5. Check Recording Number on the Clock
6. Check that Signals are reaching Destination
7. Cue-up on Clock at 10 secs

LINE-UP

The above notices should be placed in a prominent position in the VTR
operational area. They act as a permanent reminder of the correct procedure.
Instructions can vary to suit local needs.

A common assessment code for the video recording.

Impairment Grades

Several pages in this book introduce the reader to the engineers' technical language and methods of describing distortions. Unless the user is continuously making measurements and assessing the programme quality he will always be left with the question, "Yes but what does it sound and look like?" It is, after all, the final measure of quality to determine how objectionable, to the average viewer, a particular distortion really is.

To measure subjectively the quality of any programme the EBU (European Broadcasting Union) has developed an impairment scale.

Overall quality
A separate assessment is given for sound and vision which is graded from 1-6 as follows:

1. Excellent.
2. Good
3. Fairly good.
4. Rather poor.
5. Poor.
6. Very poor.

Half grades can be given if it is felt that the quality falls somewhere between two grades.

Impairment severity
If the overall quality is worse than 3 then the type of distortion and its severity should be assessed as follows.

The type of distortion may be streaking, noise, lack of definition followed by a grading.

1. Imperceptible.
2. Just perceptible.
3. Definitely perceptible.
4. Somewhat objectionable.
5. Definitely objectionable.
6. Signal unusable.

Impairment incidence
Time is the final factor which determines how objectionable a distortion appears to the viewer. A short brief period is obviously less annoying than if it occurred throughout the programme. The grading is defined as follows:

1. Occasional short bursts.
2. A single short period.
3. Occasional short periods.
4. A single prolonged period.
5. Occasional prolonged period.
6. Throughout.

Complete grading
A report on a VTR playback could be as follows.
Vision overall grade 3 Streaking 3-3 Sound overall grade 2.

If the overall grade is 3 or worse, it should be followed by a description of the type of distortion (see appendix). This is followed by the two numbers, the first indicating how severe the distortion is and the second how often it occurred.

EBU IMPAIRMENT GRADING

Occasional drop-out may be classified as grade 3–1.
Disturbing noise throughout may be classified as grade 4–6.
Complete loss of synchronisation may be classified as grade 6–6

The Recording Report

The Recording Report has several functions. It acts as a record that a recording has been made, its location on a particular tape, and its position on that tape.

It gives a record of the incoming quality which is useful when assessing where the faults originated from. The system of checking quality also keep everybody on their toes and stops technical personnel from becoming lax.

It indicates the record and playback machine used which can be useful when checking interchange problems. Finally it acts as an authorization document to erase a programme when it is no longer required. This is a safeguard against unwanted erasure of programmes or recriminations after it is realized that an erased programme was wanted after all.

The authorization should be obtainable from as few people as possible and they should be high up the production tree, probably at director of programmes level.

At least two copies of the report should be made at the time of recording. One copy should be kept with the tape and the other on a master file. The master file can be split into separate parts for existing recordings and old erased recordings. In this way recordings can be periodically reviewed for possible erasure and thereby releasing a tape for future recordings. The master copy can also be used to compile the index cards.

TVZ RECORDING REPORT

TITLE USING VIDEOTAPE		REC.No 39701		DATE 21 / 2 / '76
TAPE No T.51	VTR No 3	RECORDING ENGINEER J. F.R.		STUDIO 2
INCOMING QUALITY		SOUND OVERALL 2	STUDIO	3

SOUND FAULT	GRADE	LEVEL	VISION FAULT	GRADE	AGREED
			STREAKING	3·3	∨

03·40 – 19·20 (TAKE 1)
20·30 – 36·40 (TAKE 2) USE TAKE 2.

(CUE POINT 20·25)

PLAYBACK FAULTS ADDITIONAL TO ABOVE

DATE	VTR	SOUND	GRADE	VISION	GRADE
5/3/76	1	None	3·6	Drop outs	3·2
7/3/76	3	Noise	5·6	Drop outs	4·3

ERASURE DATE	AUTHORITY
20/5/76	W.B.Lewis.

RECORDING REPORT

The recording report should stay with the programme tape until erasure has been authorised. It should be read prior to each playback for special instructions and the programme number checked against the leader on the start of the programme.

Systematic indexing ensures information accessibility.

Keeping a Record

Any library, however comprehensive, is no better than its index. If you cannot find a particular item you might as well not have kept it.

No index is perfect and several methods of cross indexing must be considered, particularly when a library exceeds 50 tapes.

Even a small installation can build up a large quantity of tapes so that it is worthwhile starting a card index from the very beginning. Most of the information can be obtained from the 'Recording Report' and the index cards can be made out before filing the master copy.

Recording number or chronological index
The recording numbers normally follow a chronological sequence, so that one set of cards can be placed in number or chronological order.

As much information as possible should be added to the card to help the researcher.

Alphabetical index
A simple index with the cards kept in alphabetical order of titles.

Tape number index
This is only useful to determine what other recordings may be on a tape before it is erased. The minimum of information is required as further information can be obtained from Recording Number Index.

Some installations number their tapes in such a way as to identify a subject, ie. B46 Biology, P72 Physics. This can be confusing when a subject cannot be categorized or belongs to two disciplines.

Subject index
The subject is a little more complex and more than one card may be required. For instance Rec. No. 39762 could be classified under Boyle's Law, Charles Law or Physics.

These cards can be kept in alphabetical order or any other library subject system if preferred.

Other indexes
A security system may require a criminal identity index or a lost property index. An advertising agency may require a customer index. A medical school may require an operation index. The variations are limitless but the general rule is to have as many *useful* cross references as possible.

As each card takes time to make out, it is best to put all the information on one card, normally the recording number. All other cards simply refer back to that recording number.

136

REC: No 39762	DATE 10/5/'76
TITLE THE LAWS OF PHYSICS	
PRODUCER HELEN ROWETT	TAPE No T 62 .
TAPE TIMES 30·45 - 59·30 (28 min. 45 sec)	

CONTENTS *A programme giving an historical review of Boyles and Charles' Law. — Some early engravings shown.*

LAWS OF PHYSICS (THE)

Rec No: 39762.

CHARLES' LAW (HISTORY)

LAWS OF PHYSICS 39762

TAPE No	T. 62 ‿
39762	LAWS OF PHYSICS.
59764	LAWS OF BIOLOGY.

PROGRAMME CARDS

For reference, a card index should be kept, giving brief details of the programme content, duration and title. Other cards for cross references can be useful but need only refer back to the main chronological index.

The VTR Clock

The video-tape ident clock serves many purposes. It is mounted in the studio, preferably on a mobile stand and is recorded as a countdown one minute before the start of the programme.

During the recording it helps to co-ordinate all those items in the production and gives them an accurate time reference for the programme start.

For playback it helps the operator check that he has the right programme and that it agrees with the label on the box. It also helps him find the correct take if several abortive recordings were made.

Finally it gives the playback operator an exact visual and audible cue point for starting the programme. At a point where the clock reads 10 seconds to go, the replay VTR can be stopped, ready to be re-started 10 seconds before the programme is required. The playback will start at the correct time.

A typical production could start as follows:

Producer: Right is everybody ready? VTR (Reply yes), Telecine? (Yes), Sound? (Yes), Studio? (Yes). (These yes's may be replaced by cue buzzers if the areas are remote.)

Start recording VTR.

VTR (after the machine is locked) VTR running.

Producer: Start the clock.

Floor Manager: Standby; 45 seconds (at 45 seconds to start of programme); 30 seconds; 15 seconds; 10, 9, 8, 7, 6, 5, 4.

The floor manager does not say 3, 2, 1 and the mixer fades to black after 4. The floor manager signals with his hands 3-2-1- Cue. This gives at least three seconds of black and silence before the programme just in case on playback the vision mixer cuts to VTR early.

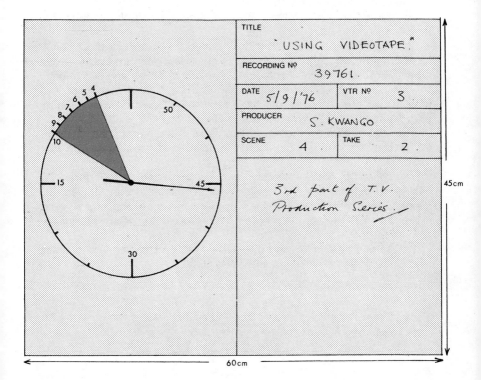

TITLE
"USING VIDEOTAPE."

RECORDING Nº 39761.

DATE 5/9/'76 VTR Nº 3.

PRODUCER S. KWANGO

SCENE 4 TAKE 2.

3rd part of T.V.
Production Series.

45cm

60cm

VTR CLOCK

At least thirty seconds of the clock should be recorded at the head of every programme giving a count down to a programme start. This can be used to check the programme number against the schedule and to give an accurate cue point prior to start of the programme.

139

The Tape Card

The number of times a tape can be used depends on the type of tape, the type of VTR, the working environment (humidity, temperature, dust content), the storage conditions and the general care taken in handling, cleaning and maintaining the VTR.

A user should get at least 200 head passes before the condition of a tape warrants rejection.

The tape may be rejected for drop-out count (audio or video), noise, head clogging or edge damage. It is obviously economical to re-use tape and therefore essential to keep a record of its use and condition.

This can best be done with a tape card which is made out and attached to the tape box when the tape is first used. It then remains with the tape for the rest of its useful life.

The information on the card simply states the general condition of the tape every time it is used and the number of head passes on that date.

The record is not completely accurate as a tape may undergo 20 passes during the first 30 minutes and 30 passes during the last 30 minutes and the card may show 50 passes. If a more accurate analysis is required then the actual programme times can be referred to on the recording report.

Before any tape is re-used the card should be checked and in cases of doubt the tape checked to assess its suitability.

TAPE No	T 61		
REC No	DATE	TAPE QUALITY	No of HEAD PASSES
39761	9/5/76	Satisfactory	ⅢⅢ ⅢⅢ II
"	27/5/76	Some D.O	ⅢⅢ I
"	2/6/76	Some D.O - Bad in places	ⅢⅢ ⅢⅢ ⅢⅢ ⅢⅢ II
39799	2/12/76	Do not use	ⅢⅢ ⅢⅢ I
"	7/1/77	"	ⅢⅢ ⅢⅢ ⅢⅢ
"	14/1/77	Rejected	
DO	NOT	USE	

TAPE No	T 62		
REC No	DATE	TAPE QUALITY	No of HEAD PASSES
39762	10/5/76	Bad D.O at	II
		31.50 m	
		(Keep recording, but	
consult site representative for free			
replacement)			

TAPE No	T 63		
REC No	DATE	TAPE QUALITY	No of HEAD PASSES
39763	11/5/76	Satisfactory	ⅢⅢ ⅢⅢ III
"	28/5/76	Edge damage	ⅢⅢ ⅢⅢ ⅢⅢ ⅢⅢ II
		for first 10 MIN	
		Audio drop out	
"	15/6/76	Tape suspect	ⅢⅢ ⅢⅢ ⅢⅢ I
		over first 30 MIN	
		Only use last 30 MIN	

THE TAPE CARD

The tape card should remain with its own tape throughout its life giving a history of its condition. It should be read every time the tape is used.

Machine and Area Log

The machine log is a sort of diary which details the daily events in the life of a machine. It is useful in answering questions like "When was the video head last replaced"? or "It seems that the capstan oscillator always needs adjustment on this machine. Or is it V.T.I.?"

The log can also act as a record of who has used the machine, when and how many hours of use it was given.

Many machines have a head-hours clock which records the number of head contact hours ie: hours of record or playback. If it does not, an estimate should be made because premature loss of a head can be claimed for.

The machine should never be used without an entry in the log. This acts as a check against any unofficial use.

A separate log should be kept for each machine.

If there is a shift system, with no overlap between the departure of one shift and the arrival of the other, then it is advisable to keep an area log book. This is common in larger installations.

The following types of comment are most useful:

"VTR 2 occasionally loses output audio, use VTR 1 and 3 for all programmes and use VTR 2 only for recording. We suspect capacitor C 26 in output stage but did not have time to investigate."

The next shift may reply:

"We changed C 26 but VTR 2 still faulty."

Apart from keeping each shift informed and saving a duplication of effort it tends to create a slight competitive element which acts as an incentive to leave everything in order.

Complaints about cleanliness of equipment, loss of tools and conditions in the area can be passed on in a friendly manner.

DATE	EVENT	HEAD HOURS	SIGN:
10/5/76	Rec: 39762	146.1	JFR.
10/5/76	P.B. 39762	147.2	JFR.
11/5/76	MAINT: CHANGED VIDEO HEAD RE-SET HOLDBACK TENSIONS	147.9	A.P.O.
12/5/76	LOANED MACHINE TO PLYMOUTH POLYTECHNIC		
15/5/76	RETURNED — MICROPHONE MISSING .	152.8	A.P.O.
16/5/76	Editing 39789 (adjusted capstan osc:)	154.2	JFR.
17/5/76	Uneven wind on take-up. Spool changed. Spool may be bent .	154.4	KEC.
			K.EC.
18/5/76	Mains fuse blew on switch -on . Replaced :- seems O.K.	154.9	
18/5/76	P.B. 39763.		

MACHINE LOG

This should be filled out by anyone who uses or maintains the machine. Every event as it occurs should be entered. It gives continuity between users and readily indicates repetitive problems.

143

Dubbing

Dubbing is the action of transferring the sound and vision from one tape to another. The original recording is often referred to as the first generation and the first dub is the second generation. A dub from the second tape to a third tape is third generation and so on. With each generation the quality deteriorates. Therefore it should be planned to produce the minimum number of generations.

If several machines are available a lot of time can be saved by making as many copies at the same time.

The output of the playback machine should be connected to the input of the record machines via a distribution amplifier.

A system *not* to be recommended, except in an emergency, is to go through each machine sequentially as this can add distortion to the signal recorded on the latter machines.

If possible the master machine should have all the accessories needed to improve playback quality: drop-out compensation, processing amplifier, timing compensators, burst equalizers.

The line-up for dubbing is exactly the same as for recording and playback although it is worth making a spot check on the quality before dubbing the full programme. Take extra care to ensure a good playback as all faults will be duplicated on the following generations.

Run-up time
One should aim at obtaining a final copy with at least 10 seconds of clean stabilized signal before the start of programme. This means that the master copy should have *at least 30 seconds* of stable signal before the programme.

The start sequence should be as follows:

 30 seconds – start playback master machine
 24 seconds – picture stabilized
 20 seconds – start record machines
 14 seconds – record machine stabilized

This allows about 4 seconds tolerance on the lock-up times of record and playback machines.

If it is thought that second generation tapes may be used for further dubbing, an extra 20 seconds is required on the times given.

Dubbing parts of programme
Sometimes it is required to record a part of a programme and remove all scenes prior to the new start point. This is simple if the record machine has an editor or the playback machine has a processor or the signal is played back through a mixer. Black level can be recorded prior to the wanted scene and then at the required point the new scene can be faded up or edit initiated.

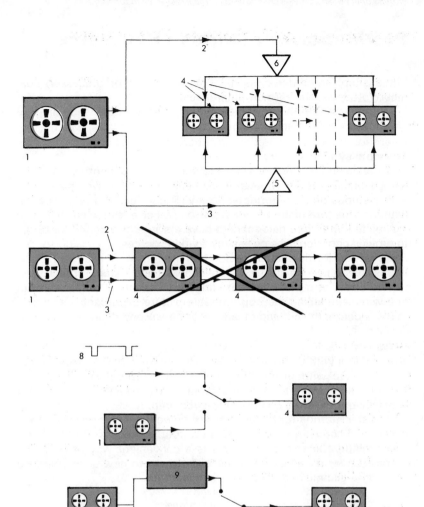

DUBBING

Multiple Dubbing
To make a large number of copies from a master (1) the video (2) and audio(3)
should be connected to the record machines (4) via a video distribution amplifier
(VDA) (6) and an audio distribution amplifier (ADA) (5).
Several record machines (4) *should not be connected in tandem* from input to
output as distortions will accumulate.

Inserting black
Unwanted scenes can be replaced with black level by recording sync pulses. If
the playback machine is not synchronous with the local source then a sync
separator can be used (9).

Production with Simple Recorders

If the simple recorder does not have an editor or processor, post record production is normally impracticable.

Without synchronous cameras and a mixer, the recording of different scenes is also difficult.

The non-sync cut
If a cut is made from one TV picture source to another, the two sources must be synchronous so as to ensure that the sync-pulse train is continuous and uninterrupted. No VTR can record a non-sync cut without a picture disturbance on playback. For a 'clean' cut between scenes it is therefore necessary to have a sync pulse generator (SPG) to provide common sync pulses to all video sources.

Simple VTRs do not play back synchronously. Consequently it is impossible to make a clean cut between VTR and a studio source.

The effect of a non sync cut varies from recorder to recorder but one way of reducing the objectionable picture disturbance is to fade to black before the cut and to fade up to new scene after.

Fading to black
The problem with this operation is to reduce the picture component of video to zero without interrupting the sync pulses (see page 38). A video level control affects both simultaneously so a special circuit for controlling the picture content only is required.

A better method for fading to black, however, is to physically cover the lens of the camera. The camera output is then simple black and syncs. With a simple camera this is a convenient way of changing scenes. Cover the lens, move camera around to new scene, remove lens cover. Simple and effective.

Adding sound
Many recorders can be switched into modes that allow either sound only or video only to be recorded.

The complexity can be reduced by preparing the introductory music, commentary and sound effects beforehand on an audio tape recorder. This sound track can be dubbed on to the VTR tape either before or after the video. If the sound is added first, it can be replayed into the studio while recording the video. In this way the demonstrator can match his actions with the sound.

The reverse is also possible where the video is recorded and the commentary added while viewing the played back video.

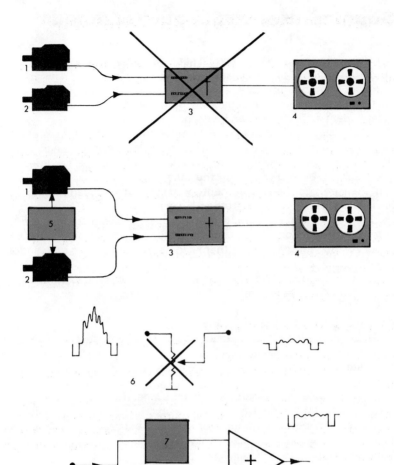

MIXING AND FADING

Two cameras (1,2) cannot be mixed (3) or cut prior to recording (4) without a common sync pulse generator (5).
Fading cannot be achieved by simply reducing the level of the signal (6) as the syncs will be reduced causing the VTR servo to go off lock.
A sync separator (7) is required with the video separated from syncs (8) and faded independently.

147

Sophisticated Production Methods

If a vision mixer is available and all sources are synchronous, then it is possible to record all the mixes, wipes, dissolves and special effects available from that mixer.

Vision can be recorded separately from the audio if desired and two independent audio tracks can be used.

For example, an international company can record two separate languages alongside the same video recording; one on each track. Alternatively, sound effects and actuality sound can be recorded on one track, and commentary on the other track. The recipient country can then re-record the commentary in its own language using the background effects to support the new version.

The most exciting possibility with more expensive recorders, is *post recording* production. Here scenes or groups of scenes are assembled on a new tape after recording them separately, sometimes in a random order.

Both pre and post production have their merits, and normally a combination of both is used.

Advantages of post production

1. More complicated productions are possible: several complex scenes can be made separately.
2. Faster cutting between scenes: less taxing on the vision and sound mixer.
3. More flexible: allows time between scenes for costume changes, setting-up tricky demonstrations, make-up, etc. Flashbacks possible.
4. Better end product (production): artists become less exhausted. Scenes with small errors can easily be repeated. Director has more time to think about individual scenes.

Disadvantages of post production

1. Technical end-product worse: second or third generation is inevitable.
2. Production can be time consuming and ties up a lot of VTR time.
3. More skill is required in VTR operations and production planning.
4. Damage to the master tape is possible, resulting in expensive retakes.

Address codes

One method for locating recorded scenes for an edit is to give each picture on tape a number or address. The address code is in the form of a digital signal and is recorded on the cue track.

148

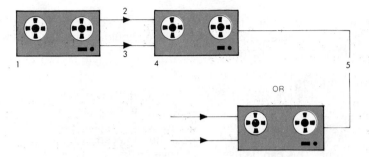

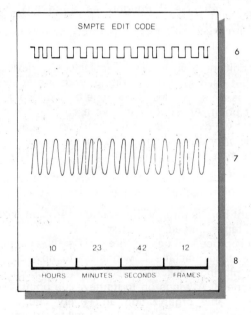

SMPTE EDIT CODE

HOURS	MINUTES	SECONDS	FRAMES
10	23	42	12

EDITING

Random scenes on one VTR (1) can be assembled by playing back the video and audio (2,3) to a second editing VTR (4). A second approach is to edit live scenes from the studio. In either case only one VTR with an editor fitted is required (5). An SMPTE address code recorded on a spare audio track (6) can identify on playback (7), during replay or spooling, every picture on tape with a unique address (8).

Editing Methods

The basic requirement is two VTRs with an editor on the record machine. If possible the playback machine should be the one with the better playback error correction.

Simple editing
Both machines are started about 10 seconds before splice and then edit is initiated at desired spot. Assemble editing (see page 100) is used to add new scenes on to the end of old ones. Insert editing is possible where a complete scene can be replaced in the middle of a programme. This can be used to remove errors or change captions to different languages.

Remember to rehearse thoroughly as some mistakes made in editing cannot be remedied.

Cue editing
This requires additionally an Editec or similar cueing device. The set-up is similar to that used for simple editing, with the added advantage that it enables us to record pips of cue-tone on the record machine and so fix the edit point. An editor can give a cut transition only at the splice point, but we can overcome this limitation, by arranging for the mix to be made *after* the editing cut. To bridge the cut, we ensure that the end of the first sequence is re-recorded as the opening of the second.

A and B Roll
The requirement here is three VTRs, sound and vision mixer, alternate scenes on two tapes, and editor on machine C.

Although this procedure ties up three VTRs, the editing time can be quite short because machine B winds on to new cue point while machine A is playing back and machine C is recording. After the transition to tape B, A winds on to its new cue point. The technique requires considerable organization and every cue point must be accurately known. The system lends itself well to automation.

One stipulation is that each recorded sequence should be long enough for the other playback machine to find its cue point, run up and stabilize.

An editor on machine C is required, if for any reason the following machine is not ready with its sequence.

150

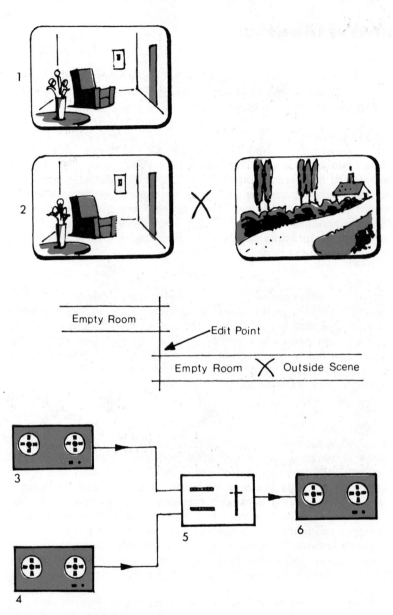

Empty Room

Edit Point

Empty Room ✕ Outside Scene

EDITING MIXES AND EFFECTS

Cut before mix
Although a VTR edit can give only a cut transition the second record sequence
(2) can start with a mix from the same scene (1).

A–B roll
The addition of a simple mixer (5), in the VTR area, allows mix and effect
transitions between two playback machines (3,4) to be recorded on a third (6).

Vision Mixer

In the course of a TV production, we often want to make a transition from one video-source to another. This can be as simple as a cut, or more elaborate in the form of wipes, mixes and special effects.

If the pictures are from non-synchronous sources such as free-running cameras, or a VTR in a non-sync mode, it is only possible to cut. Even with the simple cut, a visual disturbance in the form of a picture roll occurs, upsetting the VTR servo if the signal is being recorded. IT IS NOT POSSIBLE TO RECORD NON-SYNC CUTS.

Picture sources to be mixed must be synchronous. This requires a master sync pulse generator (SPG) to lock all sources together. If a VTR is required as a source for inserts into programmes, it should be fitted with synchronous playback facilities (Intersync or Pixlock).

If all the inputs to the mixer are synchronous, all VTRs with a video input should be capable of recording the mixer output.

A typical vision mixer consists of two or three rows of push button switches. The number of buttons in each row indicates the number of sources available; each is labelled accordingly. Two rows of buttons are marked A and B and to the right of these is a quadrant or slider fader which controls the degree of mix between the two sources selected on A and B bank. The various methods of transition can be selected: mix, wipe, cut, or special effects if supplied, but the same fader controls the transition.

The third row of push buttons selects the signal for a preview monitor which enables the vision mixer to preview a signal before transmission. Some mixers also have the facility of previewing the output of the AB mix. This is useful in setting up an effect before transmission. The extreme right hand control is a master fade to black which operates on the output of the AB mix.

152

A SIMPLE VISION MIXER

The A–B bank of switches (1) can be used to select any one of the inputs and the control (CTL) used to control the transition. The type of transition can be selected on 2.

The bottom row of switches can be used to preview any of the inputs.

The final control is a simple fade to black.

More complex mixers may have extra banks for mix and effects with a larger range of special effects. The simple arrangement shown will be adequate for most applications.

Electronic Editing Hints

Finding the edit point

Before any attempt is made to assemble the programme, preview all the available material, take scene times, approximate entry and exit points, note if the sound track is going to give any problem when a cut is made and take careful note of any continuity errors. Remember it is very difficult to take out a part of a scene, in the middle of a programme, without physically cutting the tape, whereas it is simple not to include a part of a scene when assembling a programme.

Assume that your master tape on machine A consists of several rough scenes from which you wish to assemble a final programme, on a second tape, on machine B.

1. Record the first scene on tape B by simply dubbing from A to B.
2. Find the exit point on first scene on tape B. This may be on a sound cue or a vision cue. With still frame facility, vision cues are easily found on helical machines.

Sound cues (or vision cues without still-frame, are a little more tricky). If the scene is played back and at the instant the edit is required the stop button is depressed, the tape can be marked and then backed off 2-3 inches to allow for the stop time of the VTR.

3. Find the entrance point of the 2nd scene on tape A. This can be found in a similar way. Stop the machine and mark the tape edit point with a felt pen.
4. Back off both machines 10 seconds on tape timer, and mark again.
5. Rehearse the splice by pressing both play buttons and watching both output monitors and listening to both sound tracks.
6. Decide if the edit point is correct or if exit point is early or late or if entry to new scene is early or late. Readjust tape A or B accordingly and remark tape. Make sure old mark is deleted.
7. Rehearse until satisfied, then cue up at the 10 seconds advance points, depress play button and at the correct point initiate edit.
8. The correct point depends on the type of editor. If a flying erase head is used, the edit cycle time is negligible. The edit button can therefore be depressed at 10 seconds or when the edit mark passes the reference.

If the conventional erase head is used, the editor takes a finite time ($\frac{1}{2}$ to 1 sec) to cycle. This time, which can be found in the handbook, should be allowed for by pressing the edit button earlier.

Cue tone editing

If cues are laid down on the tape to initiate edits, there is no need to allow for edit cycle time. Rehearsal is automatic by switching the record machine from playback to E-E (see page 100).

Stop Distance

Advancing the
Cue Point

MARKING THE TAPE

Stop distance
The stop distance for any machine can be determined by pressing the stop
button when a mark on the tape (2) passes a fixed point on the deck such as a
guide arm (1). A mark can then be placed on the deck (3) as a reference point.

Moving the cue
After a rehearsal the cue mark can be moved to a new position after deleting old
mark (1).

Further Reading

CARNT and TOWNSEND
Colour Television. Iliffe
Authoritative two Volume study of the theory of colour television and colour television systems.

McWILLIAMS A.A.
Tape Recording and Reproduction. Focal Press.
Theory and some practice of audio tape recording.

ROBINSON J.F.
Video Tape Recording. Theory and Practice. Focal Press.
A comprehensive theoretical study of VTR combined with a guide to current practice.

SIMS H.V.
Principles of PAL Colour Television and Related Systems. Butterworth. Theory of colour television systems with particular emphasis on the PAL system.

WHITE G.
Video Recording. Butterworth.
An outline of VTR theory and practice.

Glossary

Add-on Edit (100) See Assemble Edit.

Address Frame Number (20) Digital signal, recorded on a longitudinal track which identifies every television frame recorded on the tape. It is normally related to real time and gives hours, minutes, seconds and frames.

Amplitude (88) Peak value of a repetitive waveform.

Amtec (90) manufacturer's term for a monochrome time base corrector using sync as a reference.

Assemble Edit (100) Electronic edit where a new scene or sequence is recorded on the end of an existing recording. A new control track is recorded and only the ingoing splice is synchronous.

a.t.c. (90) manufacturer's term for a monochrome time base error corrector using sync as a reference.

Audio No. 1 Track (70) See programme audio track.

Audio No. 2 Track (70) See cue track.

Audio Signal (34) Sound signal in its electrical form.

Auto-Chroma (88) See chroma amplitude corrector.

Automatic Lock (92) 154 VTR playback condition where the playback video is in full synchronism with the station sync.

Banding (88) Effect caused by a visible difference between the heads of a quadruplex recorder.

Black Level Frequency (50) Frequency of the FM signal corresponding to the blanking level of the video signal.

Blocking Tendency of adjacent layers of tape in a roll to stick together.

Brightness (38) Adjustment which controls the average brightness of the displayed picture.

Canoe Curved section of tape between the input and output tape guides of a quadruplex recorder.

Cassette (32) Enclosed tape package containing one or two spools that allows automatic lacing of the tape path when loaded into a cassette player.

Capstan (64, 66, 78) Driven spindle in a tape machine, sometimes the motor shaft itself, which rotates in contact with the tape and pulls the tape across the transport.

Cavec (88, 90, 92) Manufacturer's term for a chroma amplitude and velocity error corrector.

CCTV (28, 110) Closed circuit television.

Chroma Amplitude Corrector (88) Device that automatically adjusts playback equalization by referring to colour burst amplitude.

Cinching (116) Wrinkling of the tape caused by a loosely wound reel pack.

Colour a.t.c. (92) Manufacturer's term for a colour time base error corrector using burst as a reference.

Colours Bars (128) Test signal giving a series of colours at 75% or 100% saturation. The colours are invariably in descending order of luminance, giving from left to right: yellow, cyan, green, magenta, red, blue.

Colortec (92) Manufacturer's term for a colour time base error corrector using colour burst as a reference.

Contrast Adjustment which controls the brightness difference between black and white portions of the displayed picture.

Cue Track (70) Area reserved on the tape for audio information relating to production requirements, electronic editing information, or a second programme signal.

Decibel (dB) (102) Ratio between two signal levels expressed logarithmically i.e.: 0dB − 1:1, 6dB − 2:1 (when referring to voltage levels).

De-emphasis Reduction in the amplitude of the high frequency components of the video signal (equal and opposite to the pre-emphasis) after demodulation.

Definition (104, 132) Presence of fine detail in the displayed picture. Loss of definition is normally caused by a loss of high frequencies.

Degauss (122) To demagnetize − achieved by subjecting the magnetized article to an alternating but decreasing magnetic field.

Downstream (70, 72) Location on the tape in the direction of the tape motion.

Drop-Out (52, 54, 86) Drop in playback RF level that causes a noticeable impairment on the playback video.

Drop-Out Count (140) The number of drop-outs per minute.

Drum See drum-scanner − Helical; head wheel − Quadruplex.

Drum-Scanner (52, 54, 56) Rotational head and cylindrical guiding assembly of a helical VTR.

Dub (82, 144) To make a copy of a recording by re-recording the copy itself.

Editec (150) Trade name for a programmed editor using cue tones.

Edit Pulse See frame pulse.

E-E (62, 154) Electronic to Electronic.

EIAJ (60) Electrical Industries Association of Japan.

Female guide See vacuum guide.

Flashback (148) Production term used to describe a return to an earlier scene.

Floor Manager (138) Person on the studio floor, who is in direct contact with the producer.

Frame Pulse (96) Pulse superimposed on the control track signal to identify the longitudinal position of a video track containing a vertical sync pulse. Used as an aid to editing and in the synchronisation of some recorders.

Freeze Frame See still frame.

Geometry Errors (92) Time base and velocity errors caused by changes in guide, head or tape dimensions or position between record and playback.

Guard Band (70, 72) Unrecorded section of tape between record tracks.

Head Channel (62) Signal path unique to each magnetic head. In a quadruplex system, the outputs of four channels are combined to provide a continuous RF signal.

Head Clogging (116) Accumulation of debris on the head, the usual result of which is a loss of signal during playback, degradation, or failure to record in the record mode.

Head Position Pulse (64) Unique tachometer pulse signifying the position of a rotating head.

Head-to-Tape Speed (48) Relative speed between tape and head during normal recording or replay.

Head Wheel (58) Rotating wheel with magnetic heads mounted on its rim.

High Band FM standard using a higher carrier frequency to improve performance on colour signals.

High Energy Tape (42) Tape with a higher coercivity and retentivity than ferric oxide. Typically cobalt-doped ferric oxide or chromium dioxide.

Horizontal Lock (92) VTR playback condition where the horizontal syncs of the video is in synchronism with station horizontal sync.

Insert Edit (100) Electronic edit where a new scene or sequence is recorded between two existing scenes. An existing control track is required which is not erased or over-recorded. Both ingoing splice and outgoing splice are synchronous.

Intersync Trade name for a fully automatic servo system.

Jitter See time base error.

Line-lock See horizontal lock.

Mistrack (116) Playback fault where the playback head is not aligned with the record track.

Mix (152) Transition between two scenes where the old scene fades up as the new fades down.

Mixer (138, 152) Device for fading, mixing and sometimes introducing special effects between sources. Separate mixers are required for sound and vision.

Moiré Coherent beat pattern normally produced by the harmonic distortion of the FM signal. It is most noticeable in large areas of large amplitude high frequencies, i.e.: colour subcarrier.

Multiburst (128) Test signal with a series of frequency bursts. The range of frequencies would typically be 500kHz, 1MHz, 3MHz, 4MHz, 5MHz.

Pix-lock See automatic lock.

Pole Tips (58) Parts of the video head which protrude radially beyond the rim of the head wheel and form the magnetic path to and from the tape.

Pre-emphasis Increase in amplitude of the high frequency components of the video signal prior to frequency modulation.

Print Through Unintentional transfer of a recorded signal from one layer of magnetic tape on to adjacent layers.

Processor (82, 94) Device which improves the playback video from one VTR by regenerating and adding clean synchronising pulses, blanking and burst.

Programme Audio Track (70, 72) Area reserved on the tape for the main audio signal, usually associated with the accompanying video recording.

Pulse Interval Modulation Form of frequency modulation.

Quadruplex (58) Four headed.

Record Current Optimizer (RCO) (126) Device that facilitates the optimum setting of the video head current by using the following head to play back a preceding recorded track.

RF 50 Modulated video signal.

RMS Root mean square. A term applied to an alternating voltage or current which gives its equivalent DC value. For a sine wave:

$$\text{Vrms} = \frac{\text{Vpk-pk}}{2\sqrt{2}}$$

RS-170 (104) Electrical Industries Association (EIA). USA – electrical performance standards for monochrome television studio facilities.

Sawtooth (130) Test signal varying from black level to peak white. When viewed on an oscilloscope it gives the effect of a series of saw teeth.

Scanner See drum scanner.

Servo Capstan (64, 66) Servomechanism which controls the rotational velocity and phase of a capstan.

Servo Head Wheel (64, 66) Servomechanism which controls the rotational velocity and phase of the head wheel.

Shoe See vacuum guide.

Shuttle See spooling.

Sound Mixer Electronic device for fading and mixing between sound signals.

Splice (mechanical) (96, 98) Butt-joint between two pieces of tape held together by means of a strip of self adhesive.

Splicing Tape (98) Self adhesive foil used to secure the butt join mechanical splice.

Spooling Movement of tape from one reel to the other without being in record or playback.

Still Frame (84) Repetitive playback of one picture.

Steaking (132) Blurring of edges after areas of black and white. The subjective effect of white streaking after white areas is normally caused by a loss of low frequencies.

Supply Reel (78) Reel from which the tape is unwound during record, reproduce or fastforward modes.

Switch-lock See vertical lock.

Sync Tip Frequency (50) Frequency of FM signal corresponding to the bottom of sync level of the video signal.

Tachometer Lock (64, 66) VTR record or playback condition where the head wheel is in phase and frequency lock with a station reference (i.e. mains, station vertical sync or input video vertical sync) from a comparison of the reference with the head position pulse.

Tach Pulse (64) Pulse derived either optically, magnetically or mechanically from the rotation of a controlled motor.

Take Up Reel (78) Reel on to which the tape is wound during the forward movement of the tape.

Tape Guides (78) Rollers or posts to position the tape correctly along its path on the tape transport.

Tape Leader (magnetic) Section of tape, usually recorded ahead of the programme material, which contains engineering alignment signal and production information.

Tape Speed Linear rate of travel of the undeformed recording medium past any stationary portion of a transport.

Tape Timer (78, 154) Clock attachment which measures the tape transported betwen the two spools. It is normally calibrated in hours, minutes and seconds.

Time Address Code See address frame numbers.

Time Base Error (90) Timing error between an off-tape video signal and a stable station source.

Tone-wheel pulse See tach pulse.

Transport (116) Mechanical assembly including the supply spool, take up spool, video and audio heads, and capstan which transport the tape during record playback and spooling.

Tip engagement See tip penetration.

Tip height See tip projection.

Tip penetration Momentary radial deflection of the tape in the vacuum guide caused by the passage of a video head pole tip.

Tip projection The measured radial difference between the pole tip and the head wheel rim.

Tip protrusion See tip projection.

Television magnetic recording See videotape recording.

Tension Servo (76) Servomechanism controlling the longitudinal tension of the tape either keeping it constant or by maintaining minimum time base error.

Track Area on the tape containing a record.

Track-curvature Deviation from straightness of a single video track record.

Tracking (74) Adjustment of the tape playback position to phase the video tracks to the rotating head.

Trailing Edge, Video Track Upstream edge of the video track.

Transverse Pertaining to dimensions or motions perpendicular to the tape travel.

Transverse Recording Quadruplex recording.

Upstream (54, 72) Location on the tape in the opposite direction of the tape motion.

Vacuum Guide (58) Part of the video head assembly used to maintain the tape in the correct position relative to the head wheel by means of a suction system.

Velocity Error (90) Rate of change of time base error, often expressed in time base error change per TV line.

Velocity Error Compensator (VEC) (90) Device that reduces the time base error changes during the line period.

Vertical Lock (66) VTR playback condition where the vertical sync of the playback video is in synchronism with station vertical sync.

Video Head Optimizer (VHO) See record current optimizer.

Video Monitor (28) Device for displaying the video signal. It is similar to a television receiver but is without the tuning and sound stages.

Video Signal (38) Vision signal including synchronising pulses.